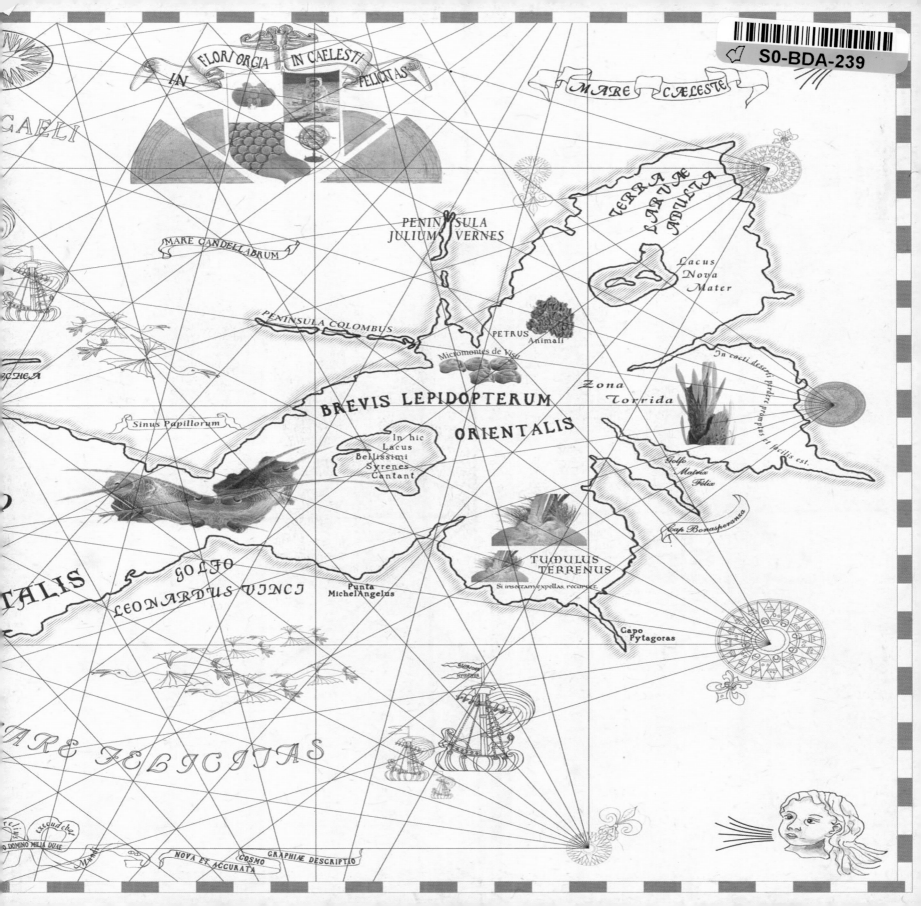

MICROWORLDS REVEALED

To Edouard, who lives in the most beautiful of all invisible worlds.

To Philippe, my dear husband, whose boundless love supported me throughout the writing of this book.

To Pierre and Mady, my parents, from whom I received scientific knowledge and artistic sensitivity.

To Philippe and Michel, my brothers, that this book may justify the admiration they have always shown me.

Hidden Beauty

MICROWORLDS REVEALED

France Bourély

Translated from the French by Laurel Hirsch

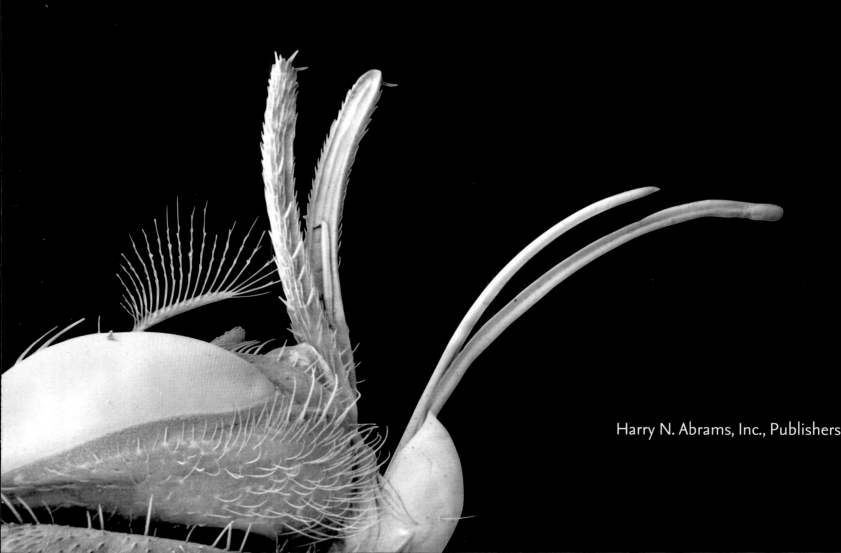

Harry N. Abrams, Inc., Publishers

CONTENTS

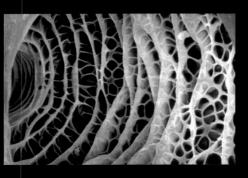

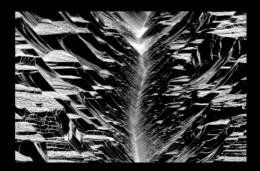

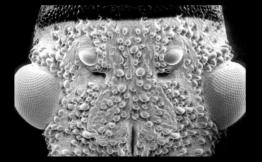

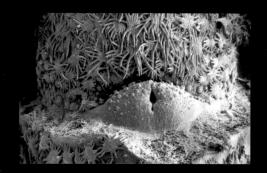

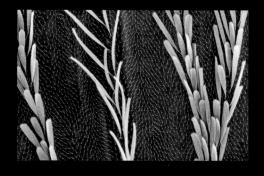

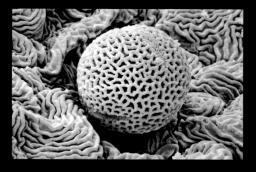

Preface

Cape Canaveral, Florida, is home to the Kennedy Space Center and the Space Shuttle. Almost everything about this place is big, of a staggering magnitude.

But not quite. In September 1995, Cape Canaveral, Florida, was also the home of a particular gnat. While most of the thousands of professional photographers who work at or visit the Kennedy Space Center have the Space Shuttle squarely in their viewfinders, France Bourély chose this particular gnat, the tiniest witness of our launch, as her focus. A few days later, while orbiting the Earth aboard the Space Shuttle Columbia, I sent an email note to France describing the sights and sensations of my first space flight. In her reply she wrote, "I see a big smile." My assumption that she was acknowledging my contentment could not have been farther off the mark. In fact, she was describing the abdomen line, magnified several thousand times in her Paris laboratory, of the gnat she had collected at the launch site. This grin, along with two "eyes" that are actually respiratory ducts on the gnat's abdomen, form the face of the "portrait" she called the Sourire Cosmique (Cosmic smile). In a world from which gigantic things hurl astronauts at great velocities into space to investigate the immense, France Bourély—the micronaut—puts the big numbers in the denominator to explore the minuscule.

This is a book of discovery; a journey into the infinitely small. Through her astonishingly striking photographs, France takes us into a world whose dimensions are as unfathomably tiny as those of space are unfathomably great.

Who among us has not turned our eyes skyward and wondered about the vastness of it all, amazed that the tiny pinpoints of light are actually gigantic fireballs that dwarf our own sun? Who has not wanted to ride some yet-to-be-invented spaceship to the boundary of the universe, just to drill a hole through it and peek to see what's on the other side? France turns that notion on its head, riding not a futuristic rocket but an equally sophisticated scanning electron microscope to open our eyes to what is every bit as fascinating—and invisible—as the other side of the universe.

Astronauts marvel at nature's beauty as they peer earthward from orbit at snow-covered mountains, rich green forests, vast desert expanses, and the deep blue of the oceans. You will be similarly astounded as you glide with France on her terrain-hugging flight, discovering new landscapes on the petal of a rose, a caterpillar's back, or the pistil of a daisy. You will come to view as spectacularly magnificent, a butterfly's eye, the foot of a fly, and a spider's skin. The astronauts can anticipate the views of the earth they will be privileged to see; globes, atlases, and photographs give them crib sheets that prepare them for the form, if not the splendor, of the sights along their journey. Nothing of the sort is true for those who accompany France on her magical odyssey. Your eyes will be opened to a realm as wondrous as a fairy tale, but as real as life itself.

Strap in and hold on—this will be a ride you will not soon forget.

—Astronaut Michael Lopez-Alegria

In 1995 at the Kennedy Space Center, while the Space Shuttle Columbia embarked astronaut Michael Lopez-Alegria for space, France Bourély picked up a gnat, the smallest witness to this grandiose event. She dedicated the photograph of it, a symbol of the joy of takeoff, to Michael. Five years later, the astronaut took it with him on his second space flight, thus making the minuscule insect travel two hundred and two times around the earth.

Preface

Are you someone who wants…to see?

Are your eyes ready to transgress the frontier of the invisible? Have you ever faced the black of night to look at the stars, dived into the depths of dark waters, rummaged under heavy rocks, or crawled through underground caves? Have you ever scaled a wall to find out what was hidden behind it, overcome your vertigo to enjoy a bird's-eye view, grappled with some mysterious text or the contents of a secret drawer? Have you searched an attic for a hidden treasure? Would you admit to having, at least once, peered through a keyhole?

If you feel you have the soul of an explorer ready to do anything to shed light on a mystery, on the impenetrable and indecipherable, or if you are simply curious, wanting truth and craving clarity, then without knowing it, you have always been a conqueror of the invisible.

Are you ready to explore the most private, the most secret, the most inaccessible universes? Then, calm your molecules, leave behind your surface tensions, and let yourself be invaded by the powers of the minuscule. Sit back, you are about to change dimensions and enter a world in which your eyes will awaken and disclose the unimaginable…

STAR
Underwater fossilized microplankton

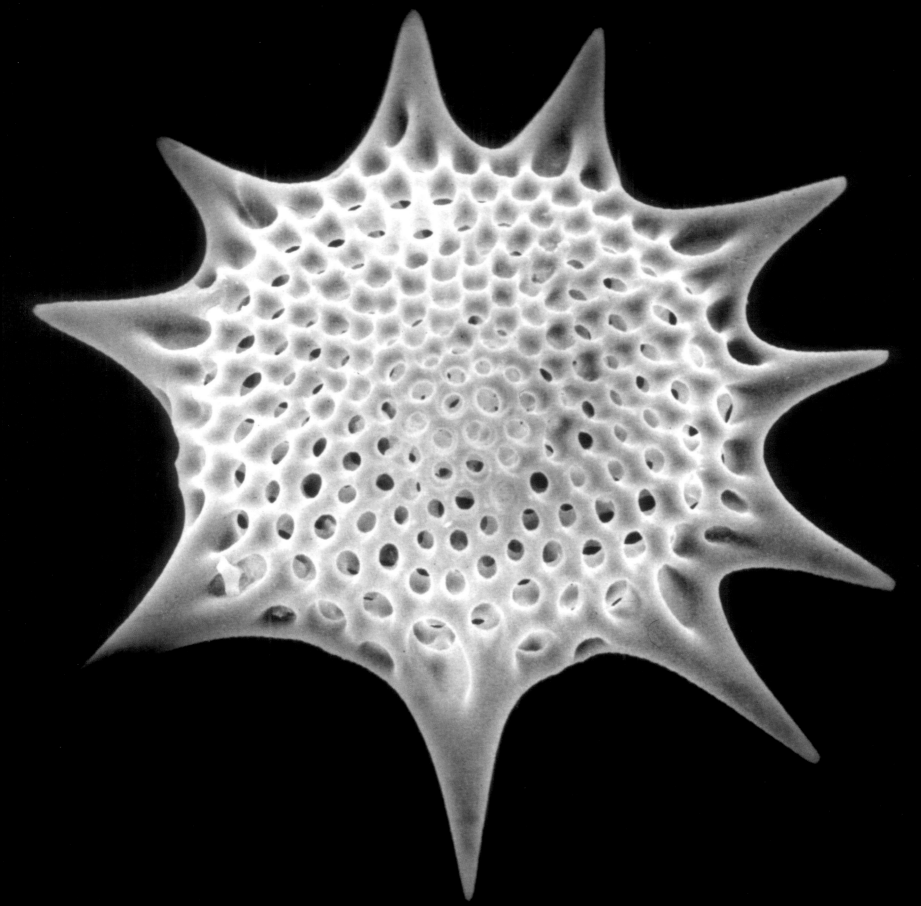

Approaching Invisible Worlds

To see a world in a grain of sand
And a heaven in a wild flower
Hold infinity in the palm of the hand.
—William Blake

Because we are as busy as bees on our tiny and fragile planet, because we feel suffocated on this cramped earth that gave birth to us, we dream of immensity and turn our eyes up to the stars. Our thoughts, searching for infinity, escape to cloudless skies and boundless lands. Yet, we tread on worlds that are so vast that no one in a single lifetime, not even a Magellan, could visit it all. The invisible is very real, it surrounds us and brushes up against us without our knowing it. Unbeknownst to us, "universes in a grain of sand" shine in the dark and their gleam illuminates our sight. The electron microscope takes us into these unsuspected worlds, opening the door to the hidden paradises in wildflowers. With it, we can touch down on those islands where no colors are reflected to contemplate the beauty of the darkness.

To experience this adventure, I drew inspiration from the lives of the first navigators of the black oceans. Along with cargo and crew, they carried geographers, scholars, draftsmen, artisans, writers, and men of faith. As I was more limited on my vessel of the infinitely small, I chose to bring along their ways of seeing to help me keep on course. Guided by their eyes, I conducted my observations from the poop deck of my microscope. Each one of them, in turn, helped me get through each stage of this journey of initiation.

In the beginning, the eyes of the explorers scouted for me. Accustomed to all kinds of tornadoes, even those of new sensations, these lovers of untouched continents led me down strange paths. Together, we penetrated the secret valleys of an orchid petal, climbed a daisy pistil, crossed mountains of pollen, and explored the gulfs of a caterpillar's back before resting in the shade of its silk bushes.

Then came the eyes of the ethnologists who escorted me through the native populations of the minuscule: knights in armor, beautiful ladies dressed in muslin, and lost tribes in the forests of feathers! We looked into their sphinx masks, contemplated the "living pillars" of their temples, and attempted to decipher the secrets of those impressive totems measuring a few microns in height.

Should we apply the perspective of the scientist or rather that of the artist to admire the exuberant symmetry and form that nature invents when it becomes intoxicated with harmony? A great mystery shrouds the origin of those plant pyramids, those silk sculptures, and those hieroglyphics of the living. If the universe has an alchemist, he is most certainly also the greatest of artists.

I humbly attempted to draw from the philosopher's vision, giving it precedence as I traveled through those strange continents. I drifted into valleys too narrow for natural light to be reflected and into never-before-seen territories existing beyond the visible. Everywhere, I discovered beauty. Yes, even in areas where, by nature, it cannot be seen. Why is the skin of this insect decorated like silk embroidery with details that are smaller than a visible wavelength? Is nature feminine to the point of preening even to an invisible degree?

Borrowing such different visions transformed my own, since within us, we all have a multitude of perspectives. To cross the frontier of the visible, we must awaken these perspectives that lie dormant behind our pupils.

Discovering the mysteries of the living need not be reserved to scientists. Truth lies hidden in the background and offers itself to free minds, to those who can open the doors of their perception. To taste the ecstasy, we all must embark upon this expedition into the vaster world and expand our consciousness of its beauty.

But now a gust of wind, filled with pollen and finely sculpted spores, rises to remind us that beauty hides in even the lightest of breezes. It is high time to raise the anchor…the invisible awaits its discoverers.

11 |

CHAPTER 1

FRONTIERS OF THE VISIBLE

WHAT IS THE INVISIBLE?

OUR OWN OBSTACLES TO VISION

What Is the Invisible?

WE ARE MORE CONNECTED TO THE INVISIBLE THAN THE VISIBLE.

—NOVALIS

During ancient times, the invisible evoked the forbidden domain where fairies, elves, and sea serpents roamed. In its sacred dimension, it has been symbolized by Mount Olympus, then by the world of souls and the divine, and today it is honored by cathedrals that reach to the heavens. The artists of the Renaissance integrated it into their works. The poets celebrated it. Galileo, who grazed the moon's craters with his telescope, was the first to introduce the invisible into our rational thinking. We now strive to possess it with sophisticated telescopes and microscopes, and even to dominate it with new penetrating sources of light. But although a door to the stars and micro-universes is now open to us, nothing can surmount the invisible. A contemporary chimera, it continues to grow as we unveil it. The invisible scoffs at us, as if it were playing hide-and-seek with our eyes.

Fluid, it takes on the shape of all that escapes our notice and we pass right by it, unaware. The minuscule butterfly eggs hidden beneath a nettle leaf, the bird we hear whistling in the undergrowth, the animal that hibernates in its cave, the insect in cracks of bark, gold nuggets buried under river rocks, hidden temples inhabited by immense octopuses.

A Chinese proverb says that if we point out the moon to an idiot, the idiot will only see the finger pointing to the moon. Too often, in so many disciplines, it is as if we were similarly blinded. Like ephemeral insects that only live for a few days, we too live within the world that surrounds us. If they only had

time to experience the crescent, could those same insects believe that the moon was round? If the brilliance of the full moon were described, would it be believed? Our vision is the proof with which we judge the world, as if the invisible were merely the effect of a reflection in a distorting mirror.

While several factors disrupt our perception, they also make it relative. Our vision is no different from the shepherd's as he contemplates the moon. Like him, we see the lit side, but what sinks into darkness remains unknown. The colors that we see are those that matter thrusts back, rather than absorbs. If the sun's rays were a monochromatic green instead of multicolored, the moon would look like a field of soft grass and our shepherd, with lime green eyes, would dream of his turquoise sheep grazing there.

Our own knowledge can also cloud our eyes. "Never does the sun see the shade," as Leonardo da Vinci noted. Do we not also cast a certain darkness over the things we see? What knowledge and what truths are held captive in this shadow, waiting to be discovered?

Our Own Obstacles to Vision

The eye acts both like an aqueduct and a power plant, transporting streams of outside light and irrigating the depths of our brains, and along its course, transforming them into absorbable electrical waves. Images are more clearly germinated. Through vision, always born from the eye-brain continuum, the familiar universe takes shape. If things existed only by the light of our perception and if our intelligence could intervene as a screen, then how would the world appear to us? Would it be in keeping with reality or deformed by our logical thinking? In order to see things as we want to see them, we often let our discernment veil over our eyes, sometimes to the point of obscuring the essential. "Man has closed himself up, till he sees all things thru the narrow chinks of his cavern," deplored the poet William Blake. He is no blinder than one who refuses to see. We must allow invigorating torrents of impression to infuse and thus enrich the current of our thoughts. Like the newborn opening his eyes onto a new world, we must welcome all pure visions and let them slowly germinate within. Like the belief in a seed's power to sprout, we must have faith in the strength of our own eyes to free us from all preconceived vision.

Christopher Columbus, obsessed with the Indies, never knew that he had reached a new continent. Jacques Cartier thought he had arrived in China when he was in what is today a part of Montreal. Sometimes researchers, in their relentless quest for precision, do not see the most obvious. I think with dread about that Indian *Mahabharata* princess who swore she would spend her whole life blindfolded. How different are we?

Our adult way of seeing is rigid, clogged, as if our illusions have turned our pupils opaque. Modern life, so concerned with appearance, might consider a return to the purity of a child's vision, rather than the mirage of youth. Our eyes do not need surgery, just a heavy dose of amazement.

It was my good fortune once again to be introduced to this power of seeing when I took Professor Don Kaplan's course at the University of California at Berkeley. A recipient of the most prestigious prizes in the field of botany, his teaching was revolutionary. He would show up with various plants and then leave us alone, instructing us to examine them carefully. "When I come back," he would say with a teasing smile, "I'll show you what you should have seen if you had eyes." An hour later, he would lead us to discover the "obvious" details we had not noticed. What had been invisible a few moments earlier, would leap up before our eyes and, as if by magic, we would see how the species existed. This is how we learned, without a textbook, falling into a carnivorous plant, observing the problems a cactus or an edelweiss encounters to survive, or outwitting an orchid's strategy to disguise itself as an insect. In this apprenticeship of seeing, I was hindered by my overly classical French education. During my schooling, I had to memorize pages of botanical descriptions, passages steeped in jargon that inhibited simple observation. The university, as Bergson had feared, did not teach us to see things, but only the labels attached to them. Something like teaching sculpture to students by tying their hands behind their backs. I went to California more to enrich myself with another perspective than to earn a degree. My eyes had learned to remove the veneer of appearance. Like Aladdin who rubbed his lamp in order to bring out a genie, we only have to let the light "rub" our pupils and the living proof of the universe's great genius will rise up before us.

Brave the light and you will discover the universe.

—Turner

Flamenco

Legs of a glowworm

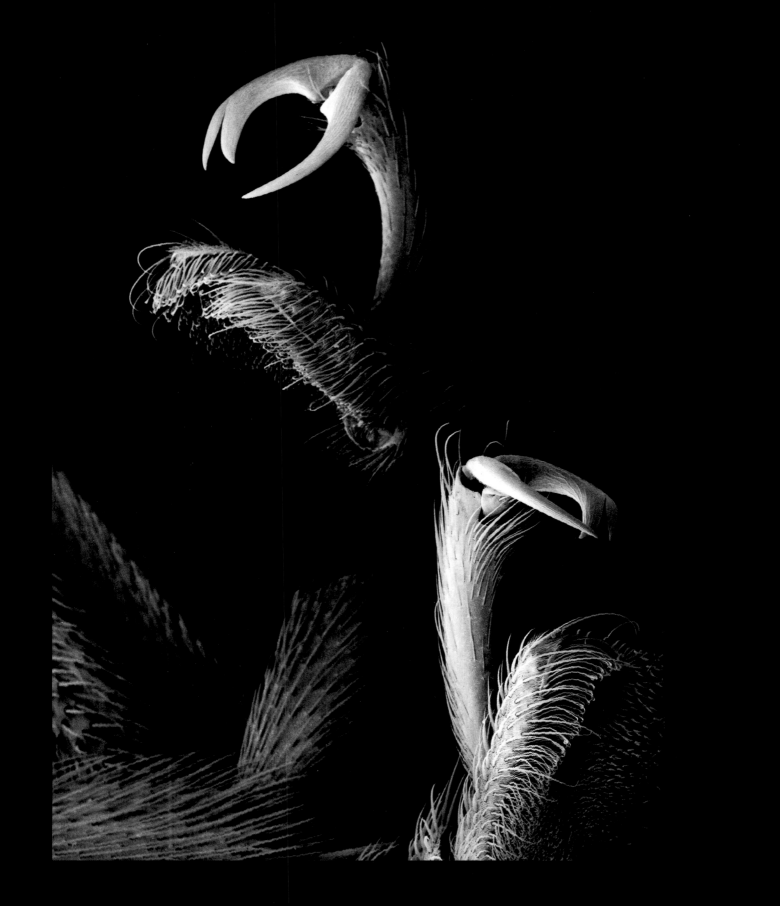

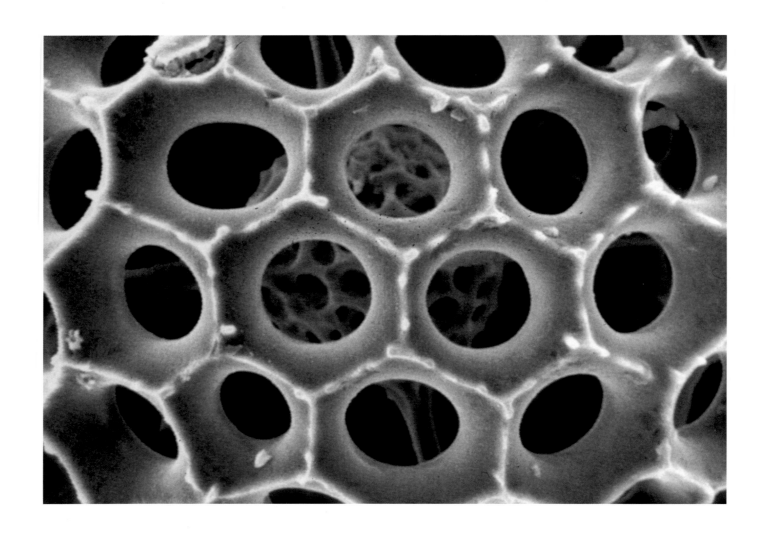

MOON WITHIN A MOON

Close-up

UNDERWATER FRIENDSHIP

Fossilized microplankton

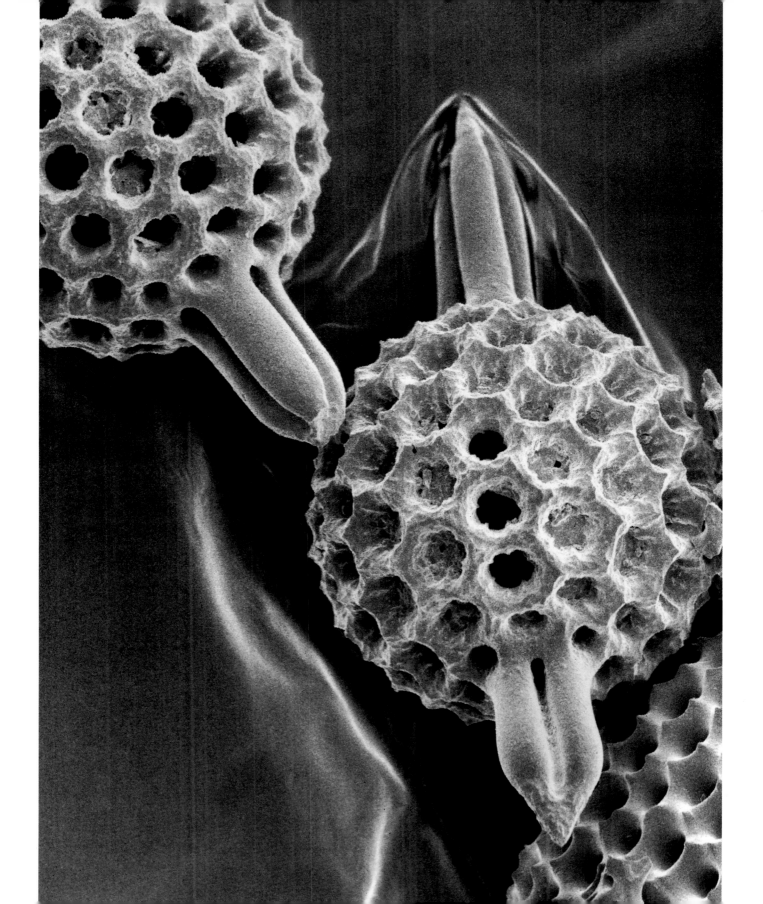

LIGHT EXISTS IN DARKNESS. DO NOT SEE WITH DARK VISION.

—ZEN KOAN

POLYPTYCH

Various fossilized microplankton

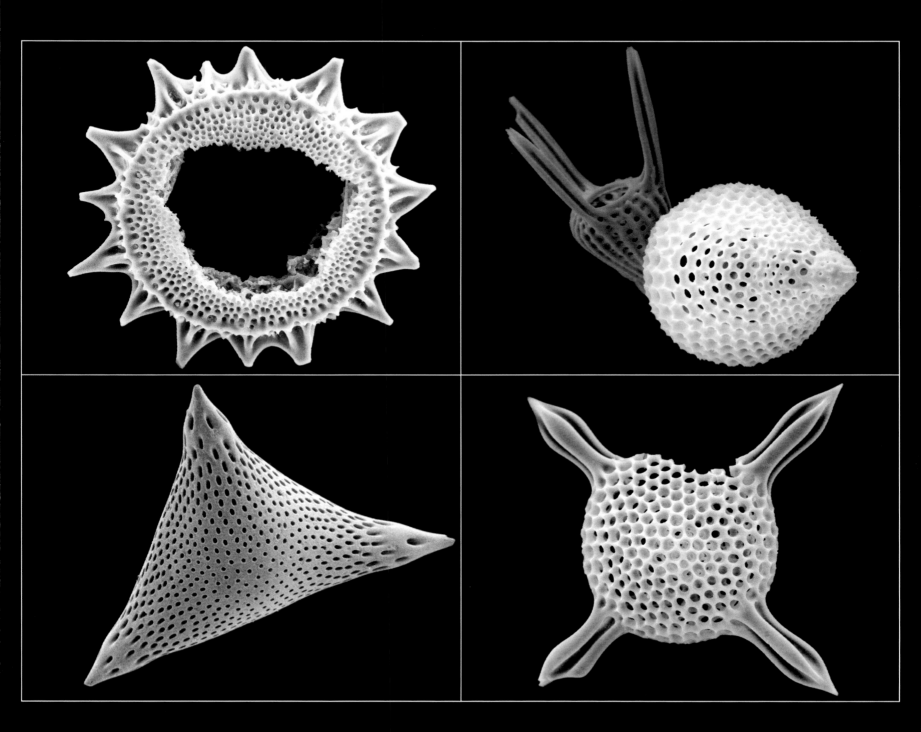

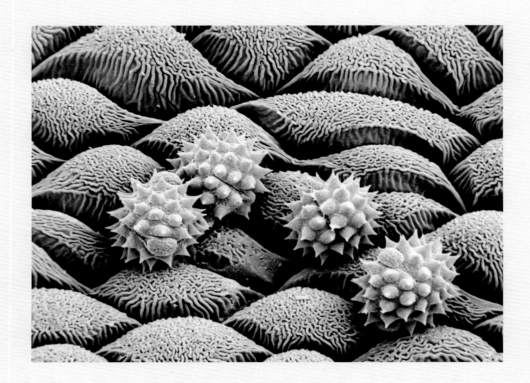

So much knowledge is locked in this darkness,

waiting to be revealed to us.

Intimate Secrets

Hibiscus petals and detail

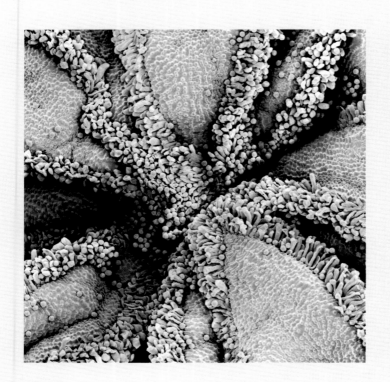 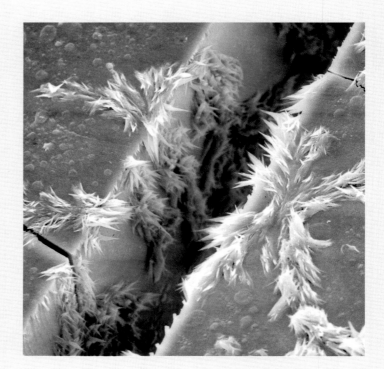

VALLEYS OF SATIN

Poppy fruit

CANYON

Birth of zeolite crystals

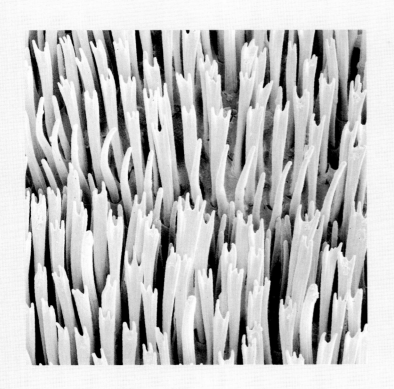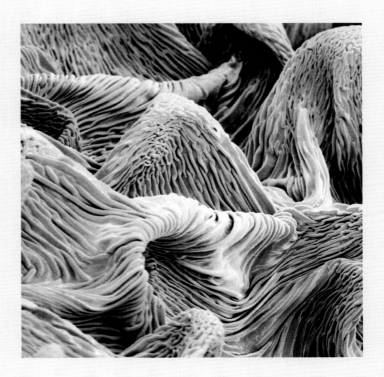

PEAKS

Detail of insect antenna

SWIRLS

Orchid petal

MOUNT VENUS

Blue hyacinth pistil

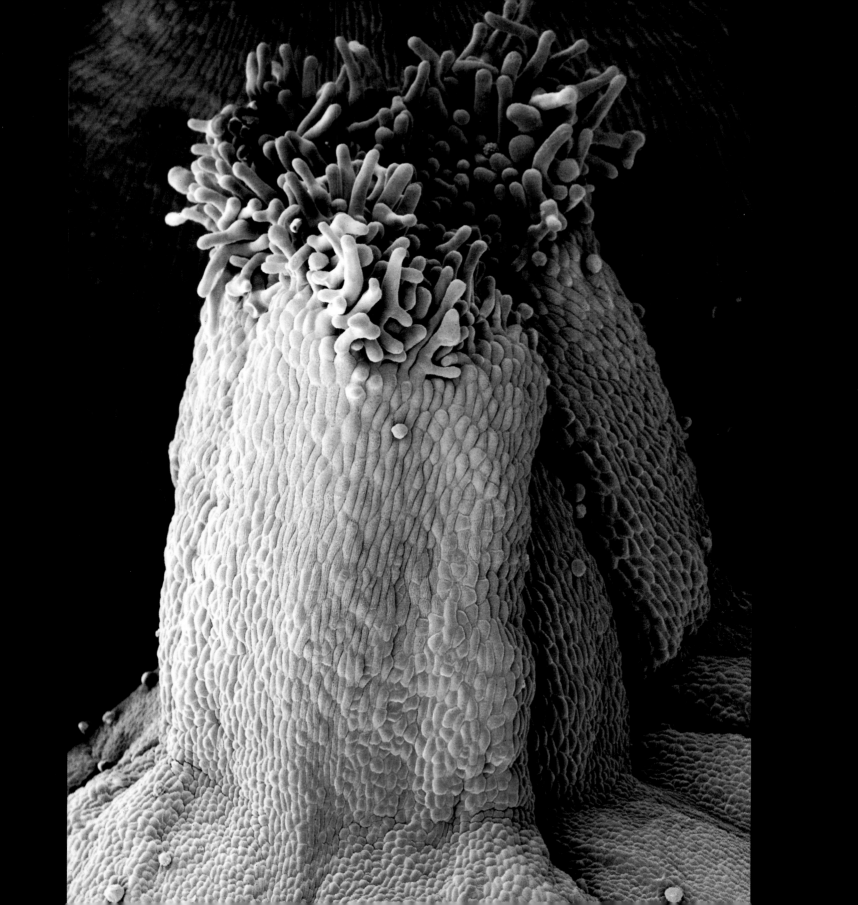

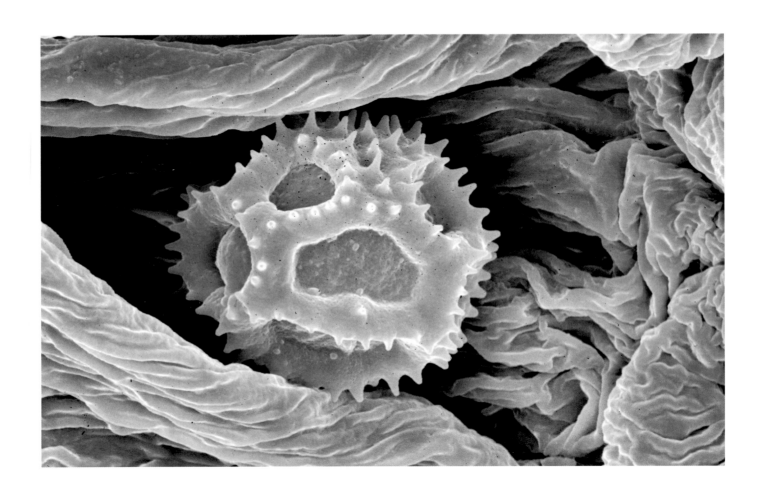

CARRIED BY THE WIND

Close-up of blue hyacinth pistil

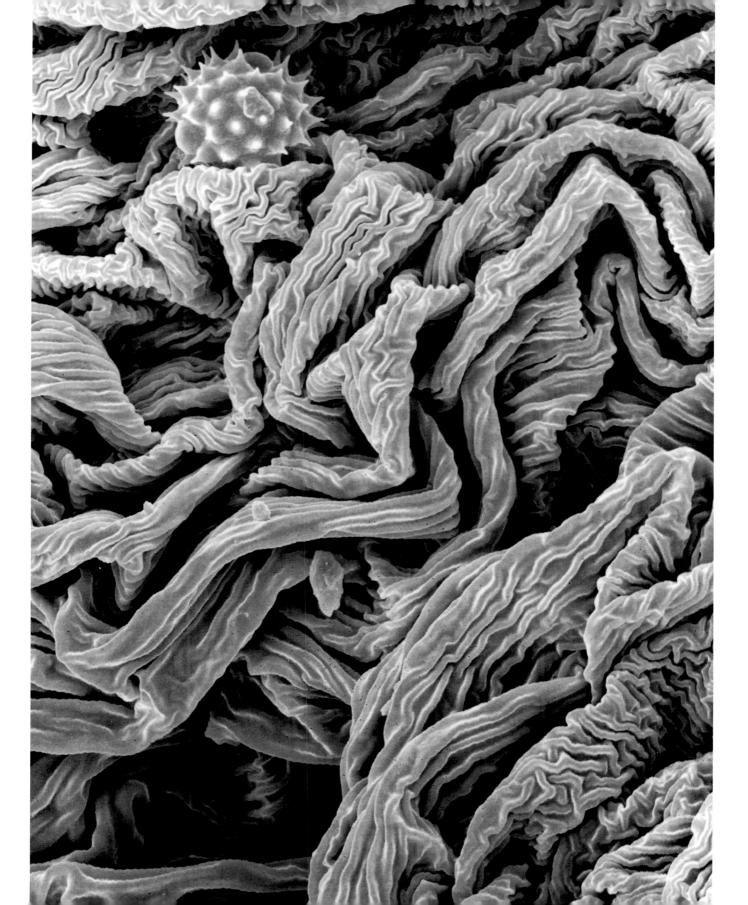

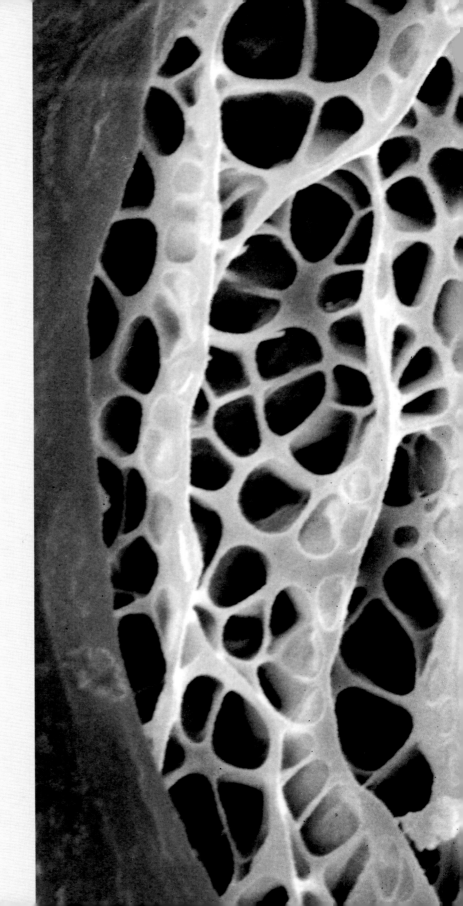

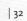

DOORS OF PERCEPTION

Pore of a scorpion claw

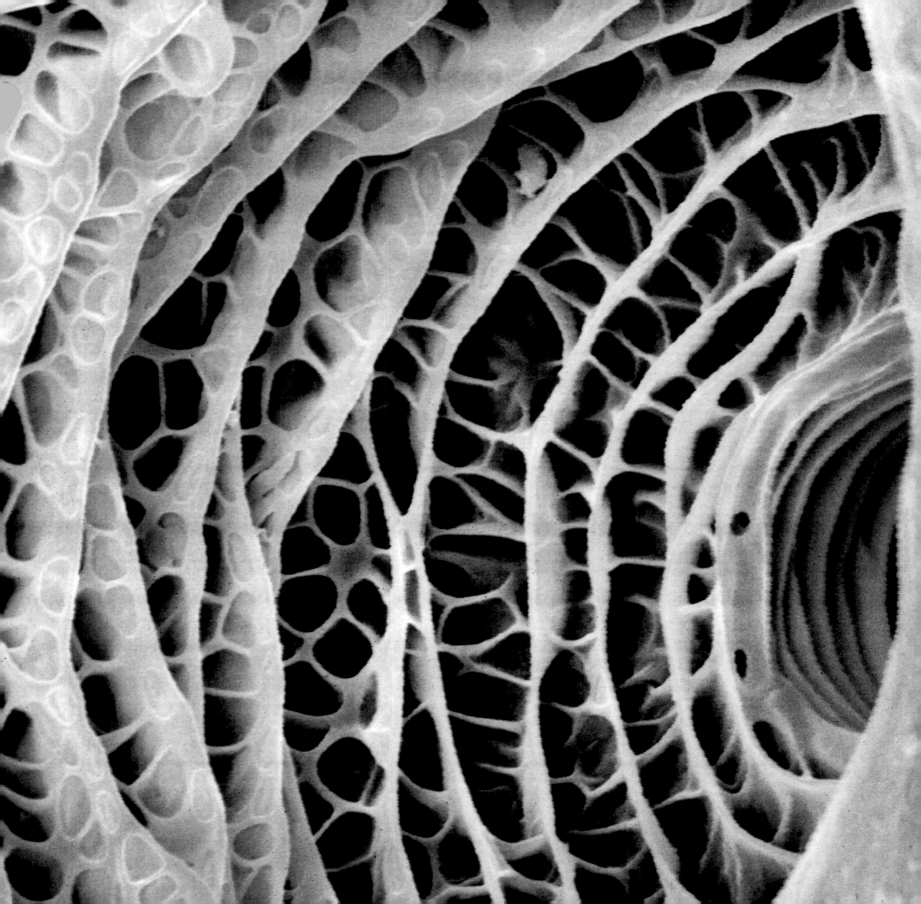

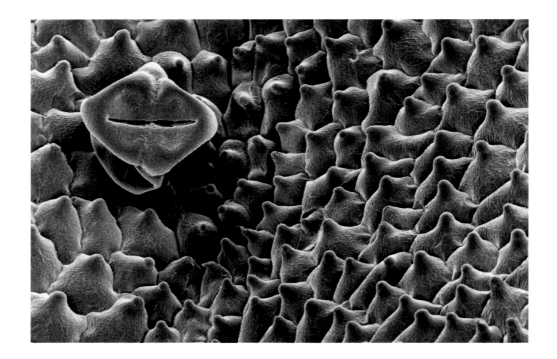

DALI'S DREAM

Pollen produced by stamen

FERTILITY

Male sexual organ (stamen) of strawberry-tree flower

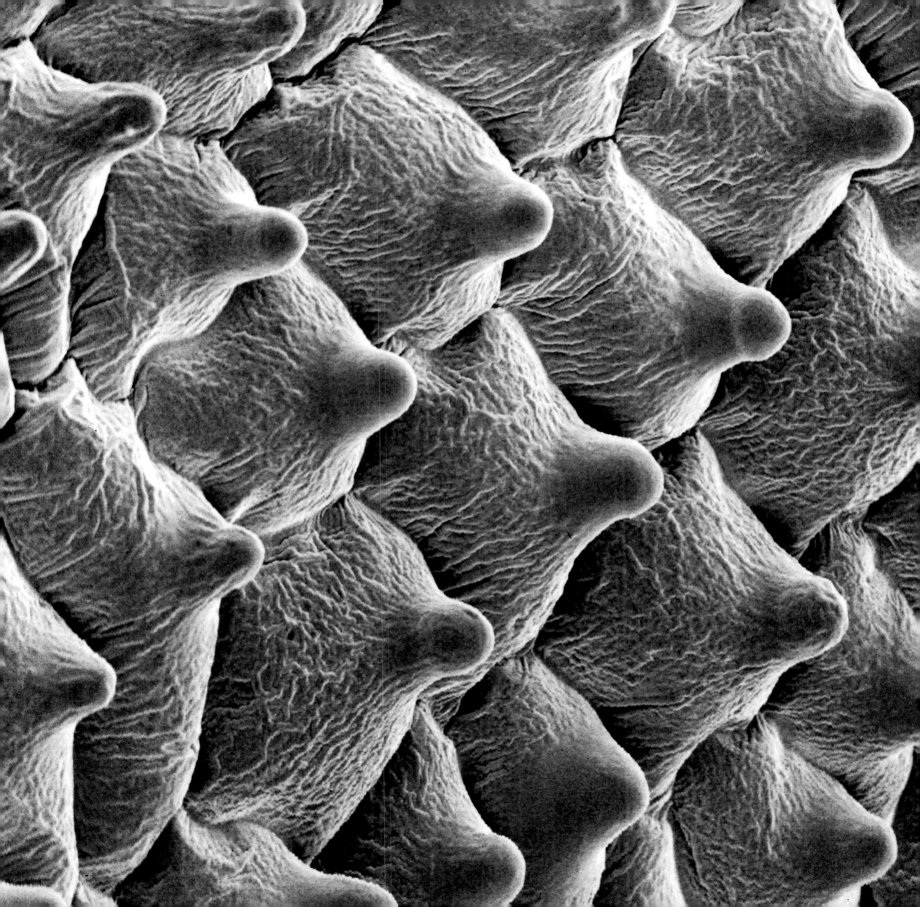

Like the belief in a seed's power to sprout,

we must have faith in the strength of our own eyes

to free us from all preconceived vision.

Zen

Underside of weevil leg

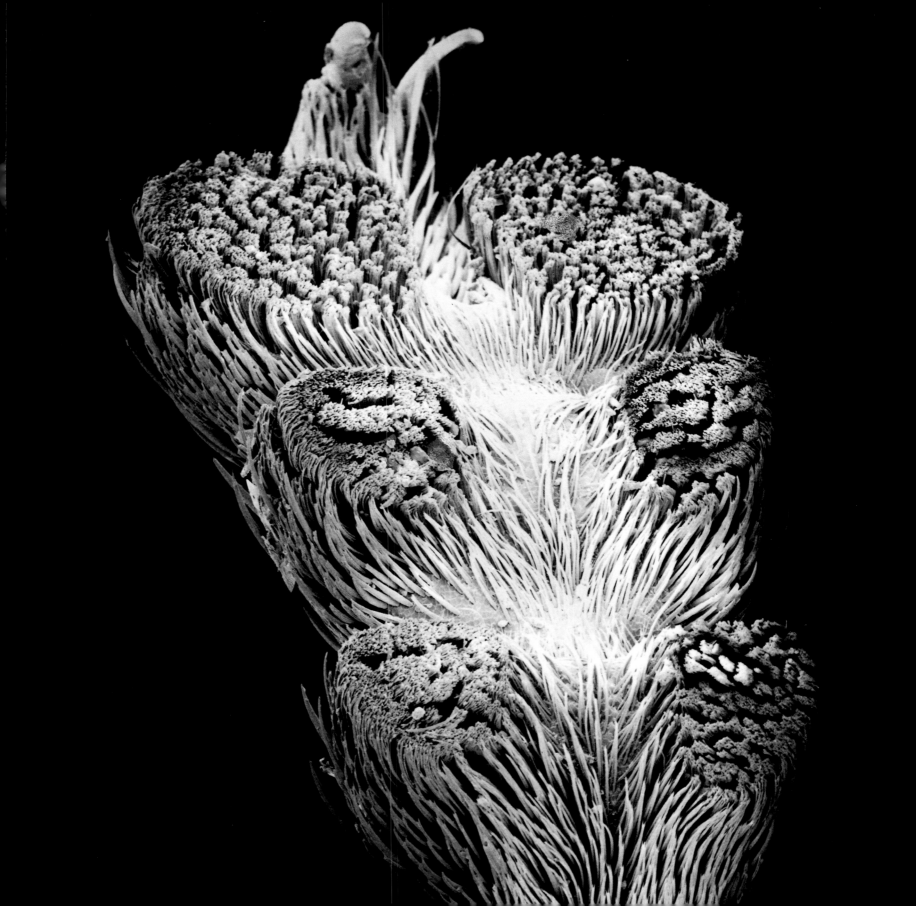

Salt crystals on jellyfish skin and close-up of crystal

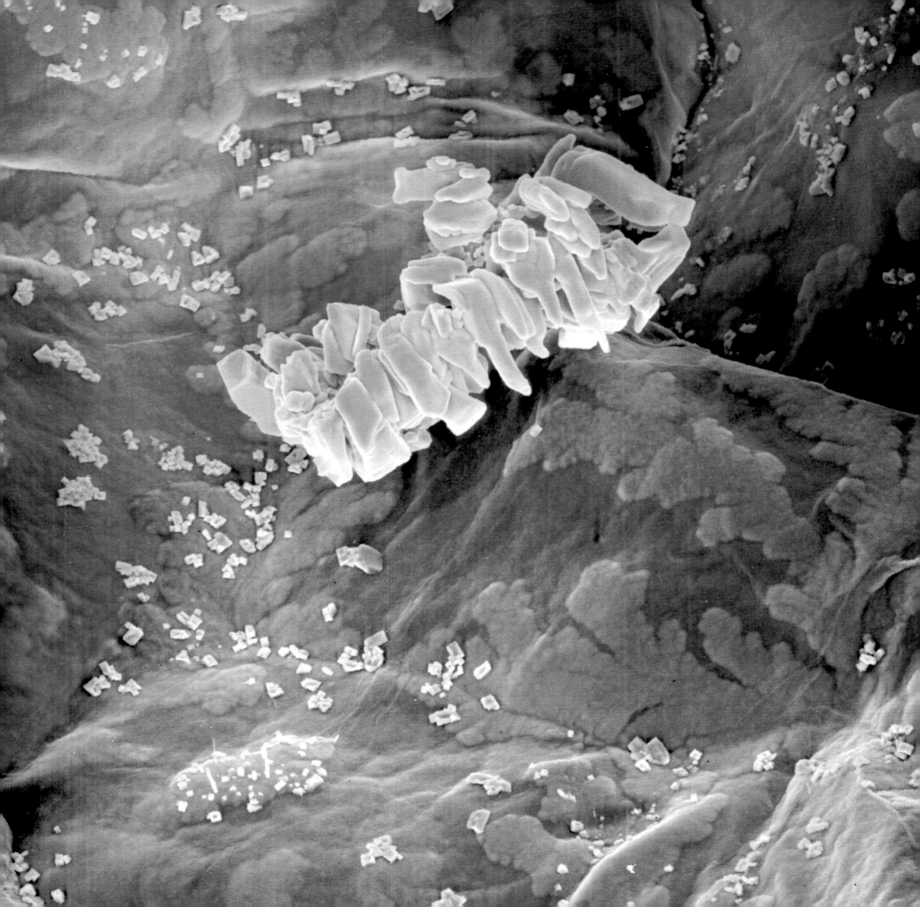

CHAPTER II

INVISIBLE CONTINENTS

DOWN THE TRAIL OF THE EXPLORERS

ADVENTURES INTO THE STRANGE

SUBMERGED TEMPLES AND TREASURES

Down the Trail of the Explorers

How can one live without the unknown ahead?
—René Char

My first visual crash with the "unimaginable" dates back more than thirty years. I was a little girl, but I remember it clearly. It was July 21, 1969. Neil Armstrong, the first man on the moon, expressed in a few words what continues to amaze me even to this day and has forever changed our vision of the sky. This event got an entire Corsican village out of bed and brought us together, young and old, in front of the only television. I was fascinated by the Apollo capsule, that metallic insect that had come looking for me in my old house of burning stones and took me to that other world of icy shadows and ghostly glows. From that point on, I was enthralled. Transformed into an astronaut, my dreams took me to dark regions and when I awoke, I would feel like a Martian lost on earth.

I would again feel that almost hypnotic vertigo during a months-long expedition to the Arctic. Standing on a frozen ocean, the air intensely cold, I gazed upon the unreal and changing colors of an Aurora Borealis. Only those who have walked on a frozen sea rippling with phosphorescent waves can understand this exhilaration. Then and there I promised myself to fulfill my passion for boundless spaces.

The Norwegian explorer Amundsen, when still a child, swore that no one would reach the North Pole before him. The first person to get to the South Pole, he wrote, "never was a childhood dream fulfilled in such a diametrically opposed fashion." To a lesser extent, when I entered the biology department at the University of California at Berkeley, I did not suspect that I would be able, in the infinitely small, to realize my wildest lunar dreams.

The scanning electron microscope, telescope to the minuscule, is huge in terms of size and weight. With its luminous screens, control desks, levers and tubes of all sizes, it takes up an entire room. It was presented to me as a precious instrument of high technology that would help me in my research on the genesis of plant cells. I hesitated taking the leap and learning about it which, at the time, was difficult. Nevertheless, it piqued my curiosity because it was carefully hidden in the back of an underground laboratory next to a garden. You needed several signatures of authorization and a special key to get in. The few initiates jealously watched over it and often, in a low voice, would imitate the whirring sounds of its vacuum pump. Sometimes, it would leak nitrogen vapors. In some abstract way, I felt there was a secret behind the respect that the researchers paid the microscope—and I was determined to discover it.

Both my scientific rigor and my passion for images convinced me to take the plunge. What bliss it was finally to find myself alone in control of the microscope, for it was then that I realized its true power. The fact that this "device" had to be parked at the frontier of the earthly world should have raised my suspicions. My first experience was as brutal as jumping into weightlessness. I had barely touched a few pressure valves and made a few adjustments before I was abruptly projected into another dimension. I found myself shrunken to the state of a human microbe, exiled to vast cellular plains. With a single burst of electrons, this spaceship into the infinitely small took me over the frontier of the invisible and landed me in worlds inaccessible to man.

After several hours in flight, I finally learned how to pilot my machine. Soaring, zooming, bursting, and then plunging into low flight allowed me to take my first "trip around the world" of a clump of grass. I slithered through the velvety valleys of a rose petal, slid on the smooth hills of a butterfly eye. Deserts, volcanoes, and deep pits. I effortlessly soared over these lunar landscapes, plunging deep into satin caverns, navigating vast mountains, and spinning around organic peaks, ever astounded by the immensity of these minuscule plains.

When I think about it today, I can say that it was not the pursuit of a degree, but rather the opportunity to voyage to the invisible that got me through those long hours of research. As an ancient Greek proverb declares, "it is not necessary to live, it is necessary to navigate." Our Paleolithic ancestors crossed the earth and its continents. Were they really hungry for the hunt? I prefer to think that they had the same hunger for discovery and spirit of adventure that continues to drive us today. Consider how natural it is for a child to explore. It is the unique and insatiable human curiosity that brings progress.

Adventures into the Strange

THE MORE WE DELVE INTO THE UNKNOWN, THE MORE IT SEEMS IMMENSE AND MARVELOUS.
—CHARLES LINDBERGH

Changing dimensions adds to the pleasure of adventure. Who has not dreamed of traveling with Gulliver to Lilliput or of following Mary Poppins into her chalk paintings? The electron microscope makes that dream come true, and what is unique about crossing its microscopic latitudes is the sensation of entering a world in which we are absent and then discovering it. These territories emerge from darkness, untouched, limpid, and preserved from the human eye. Even today, after years of expeditions into the invisible, I never know in advance what I am going to find nor what singular panorama I will have to face. I can spend a week traveling on the back of a tiny caterpillar, without ever seeing the same landscape twice, continually struck by its diversity. Volcanoes, pits, mountains, and seas are there for me to discover. Unique, unsullied since time immemorial.

Certainly, I travel this *terra incognita* with less merit than Captain Cook, but then again, I have no map to guide me. I wander freely and bypass anonymous bays and nameless capes. Ptolemy, Mercator, would they have been able to map these boundless worlds? There is no geographer who could, with any certainty, define the borders of the transforming continent that is the caterpillar during its metamorphosis. No surveyor could conceive of measuring the seismic tremors capable of changing mountains into valleys and giant silk forests into bronze fields of scales. What Herzog could climb an "Annapurna" that began to liquefy before he reached the summit? What Humboldt could tell us the secrets of the icy currents that transform the chrysalis at the bottom of a cocoon?

For my samples, I always prefer insects of the least scientific interest and the most common wildflowers with neither medicinal nor food value. Primarily, I do so to be sure that I am the first explorer, and so fulfill my childhood ambitions. My imagination is fired, my soul is like Magellan's as I near unknown shores. Who knows what I will discover there? Clearly, I do not risk being devoured by cannibals, succumbing to scurvy, or like La Pérouse, smashing against a reef, but I am submerged by waves of emotions to the point that it is difficult to maneuver the rudder of my microscope-vessel. The etymology of the word adventure (*adventura* in Latin) indicates not a journey, but rather an "event," an emotional shock that shakes the senses.

NASA takes years to prepare its astronauts before launching them into space. Intelligence is tested, but above all, so is their composure. And then they are readied for the internal shock, the extreme adventure that is orbital flight. But in truth, I think that their training, which is meant to harden them, succeeds in sharpening new sensibilities. Like the tenor who, after months of practicing, finds he has deeper tones on the very night of the recital. Just listen to a cockpit recording of the *Columbia* Space Shuttle astronauts. Conditioned to maintain a sense of calm under all circumstances, these heroes of the highest technology howled with childlike joy the moment their bodies began to float in weightlessness. Witnessing a space shuttle launch up close is a moving experience—one of those events in which humanity can take pride. It was there, at Cape Canaveral, that I was named "micronaut" by the astronauts. My own experience of launching into another dimension is clearly free of any risk

and surely less exalting, but I have had a taste of their exhilaration. And I believe, like the poet Walt Whitman, "a leaf of grass is no less than the journey-work of the stars." Like astronauts, though more modestly, I discover extraterrestrial craters where other physical constraints are imposed. I escape from the visible, just as they escape the atmosphere. I take a similar flight from earth, as I am as beyond the reach of the infinitely small as they are that of faraway galaxies. We drift in opposite directions toward the ends of a world bordering unknown universes. A contemplative elation takes hold of us, transforms our inner horizon, and awakens within us a common consciousness of the cosmos.

I was delighted by the nickname micronaut. To thank these astronauts and also to pay homage to the great Jules Verne who "invented" them, I named my microscope the *micronautilus*.

Submerged Temples and Treasures

THE COURAGE OF THE DROP OF WATER IS THAT IT DARES TO FALL IN THE DESERT.

—LAO SHE

Life is like water—wherever it surfaces, it seeks to expand and occupy the largest space possible. Fluid, it molds itself into the most perfect and exotic shapes. It does not worry about letting some of its "branches" run dry if doing so enables a flow into new territories. It swirls, ready for any flood, even to defy the laws of gravity. There is no better motto for it than Seneca's: "If the way doesn't exist, invent it." What we call evolution is the result of this fertile inundation and shunning uniformity, these waters are never stagnant. A deluge of life seems to spring from an inexhaustible reservoir. The sole river of insects overflows with a million species so overwhelmingly diverse in morphology that their profound unity is eclipsed. Beneath the hardest of shells, beneath a green cuticle, always flows the same nutritive sap. In the beginning there was water....As if all forms of life were but an invention of water so as to better spread without the risk of running dry!

In the monotonous depths of the first ocean, perhaps a drop of water dreamed of conquering land. The primitive ocean, lightly salted, engendered the first living cells and filled them with liquid. Then, over a period of some three billion years, the ocean grew rich with the salt and minerals carried by the rivers. Both sap and human blood, however, have retained their weak saline concentration, and thus, living beings perpetuate within themselves the memory of the waters of their origins.

While piloting micronautilus, I immerse myself in the invisible and the variety of living forms becomes even more striking. All insect antennae do not look alike: on one may be a pyramid of soft and translucent balls, while on another, strange pineapples in some mysterious configuration. Then, farther away, are deep pits that conceal even more inaccessible unknowns. Forests of lashes hide clearings that appear to shelter even more minus-

cule beings. Temples, refinely ornamented, show up here and there. A Doric column hides in the silky marble of this spider's thread. According to what architectural calculations does this obelisk rise up before a soft wisteria shoot? Who sculpted these flowing arabesques and in honor of whose spring wedding are these gossamer garlands that float on butterfly wings?

I dream of Schliemann discovering the ruins of the city of Troy. He was searching for his own pleasure, as an amateur, and brought down the wrath of professional archaeologists. Passion, however, is the key to all discovery and must be protected from the rust of academia. While in the desert, Saint-Exupéry learned that "the essential is invisible to the eyes," and I have discovered that even with this fabulous visual prosthesis of a microscope, "we only see well with the heart." I give mine free rein, allowing it to saunter wherever the electron currents lead. I contemplate Atlantises engulfed in the invisible, but do not try to decipher the hieroglyphics that come to me one by one. I prefer to steep myself gradually in the feeling that they have meaning. I dive into this native beauty of the world and this fulfills my contemplative happiness.

I DID NOT SUSPECT THAT I WOULD BE ABLE, IN THE infinitely small,

TO REALIZE MY WILDEST LUNAR DREAMS.

INVISIBLE PLANET

Eye of Brazilian bug

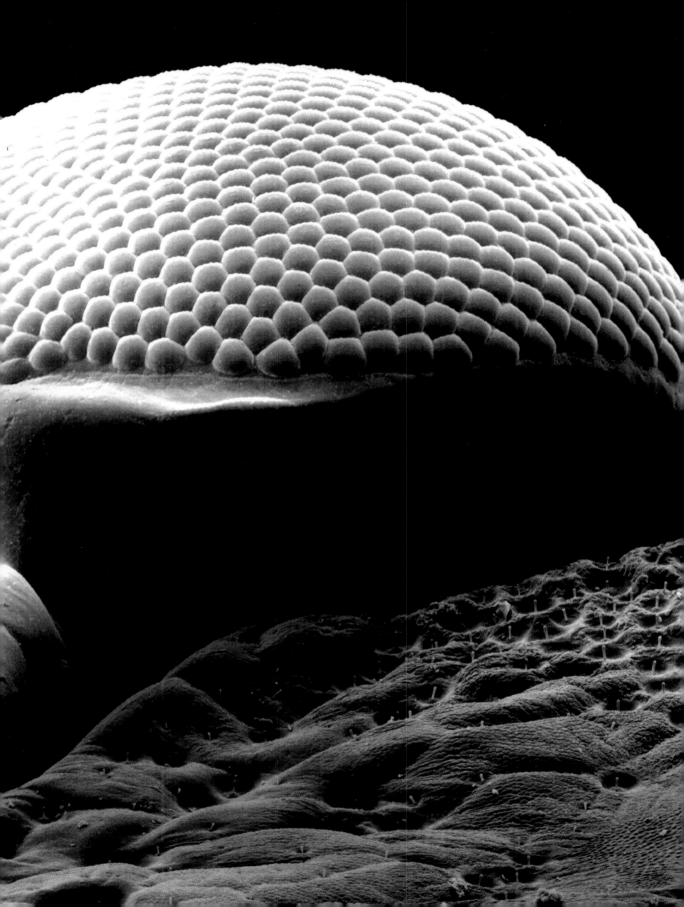

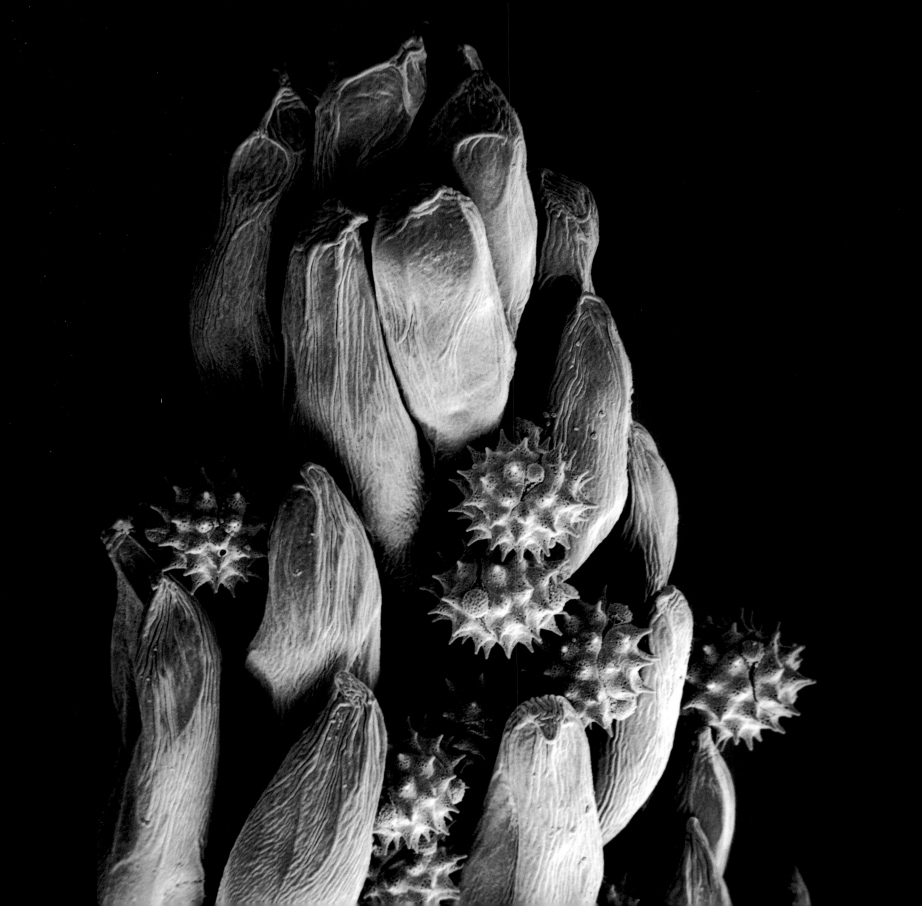

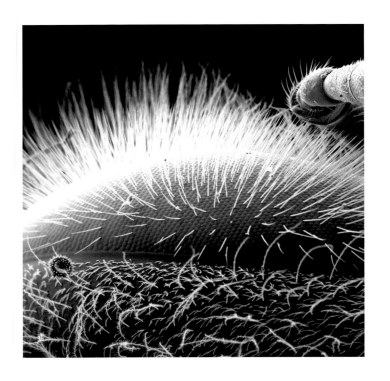
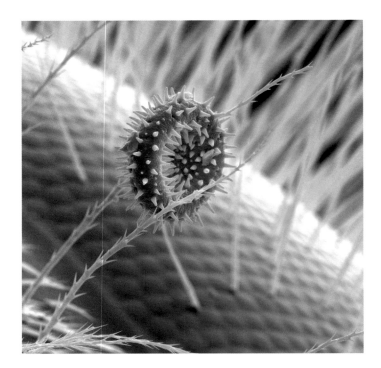

A L I E N S

Close-up of pollen in the "lashes" of a bee

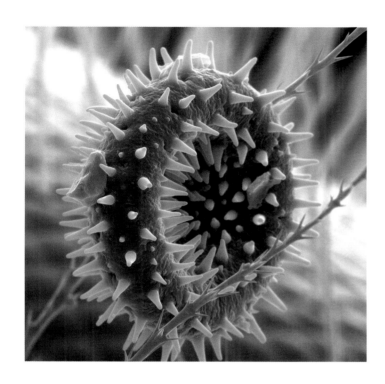

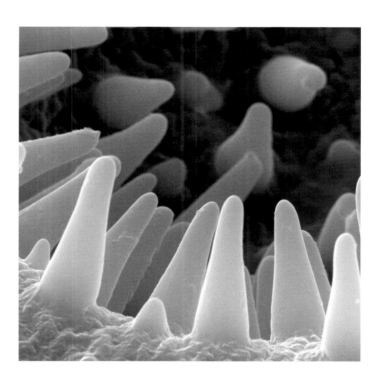

FORESTS OF LASHES CONCEAL CLEARINGS THAT SEEM TO BE INHABITED

BY OTHER, EVEN MORE MINUSCULE BEINGS.

IF YOU STARE DEEP INTO THE ABYSS,

THE ABYSS WILL LOOK BACK.

—FRIEDRICH NIETZSCHE

THE BLACK HOLE

Detail of unidentified mineral

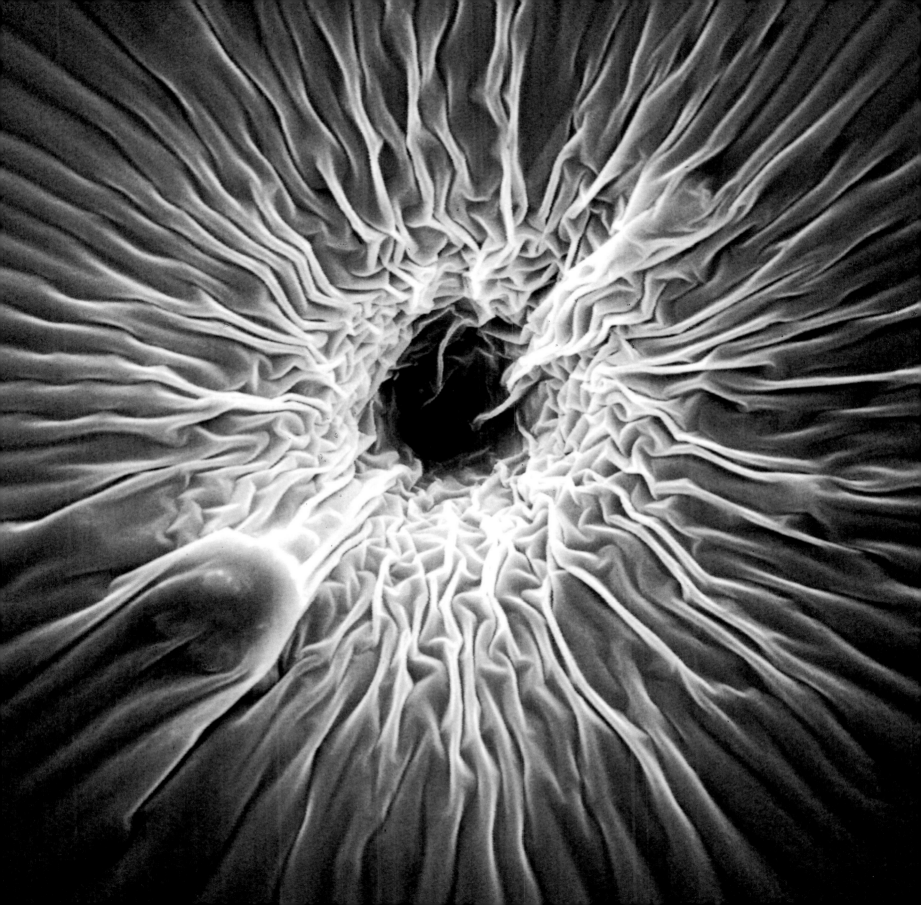

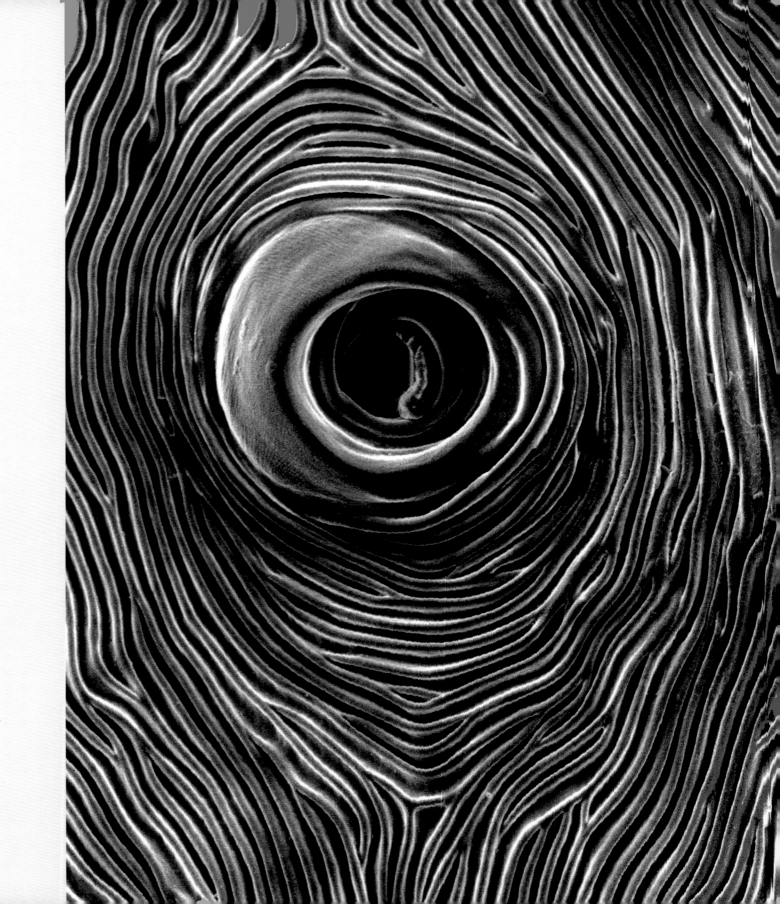

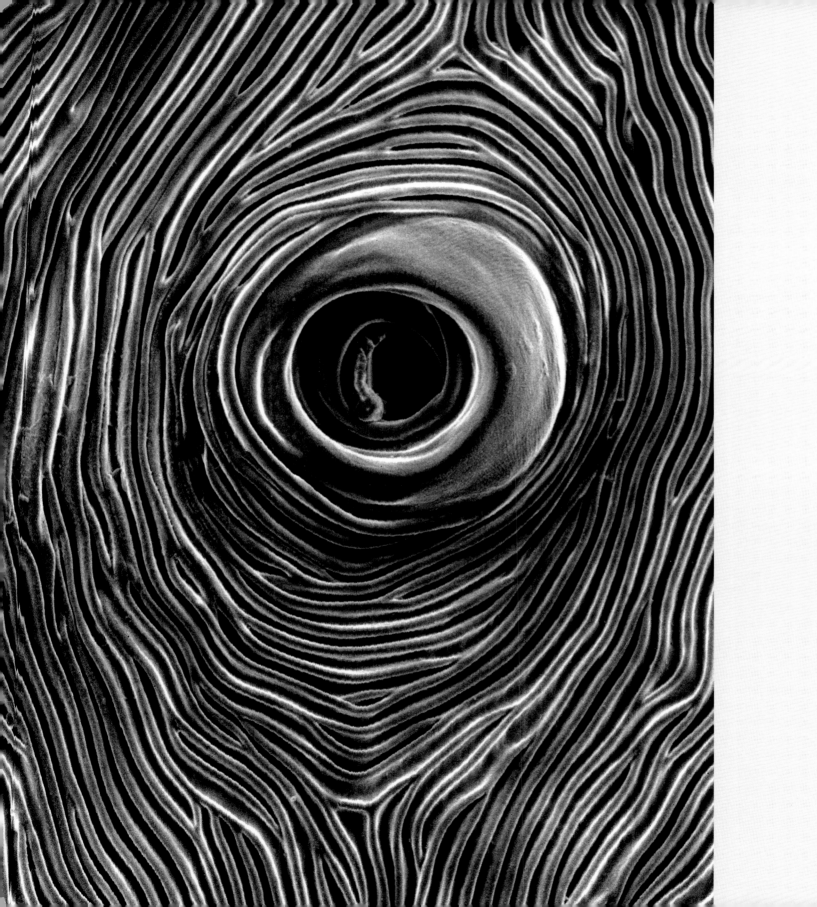

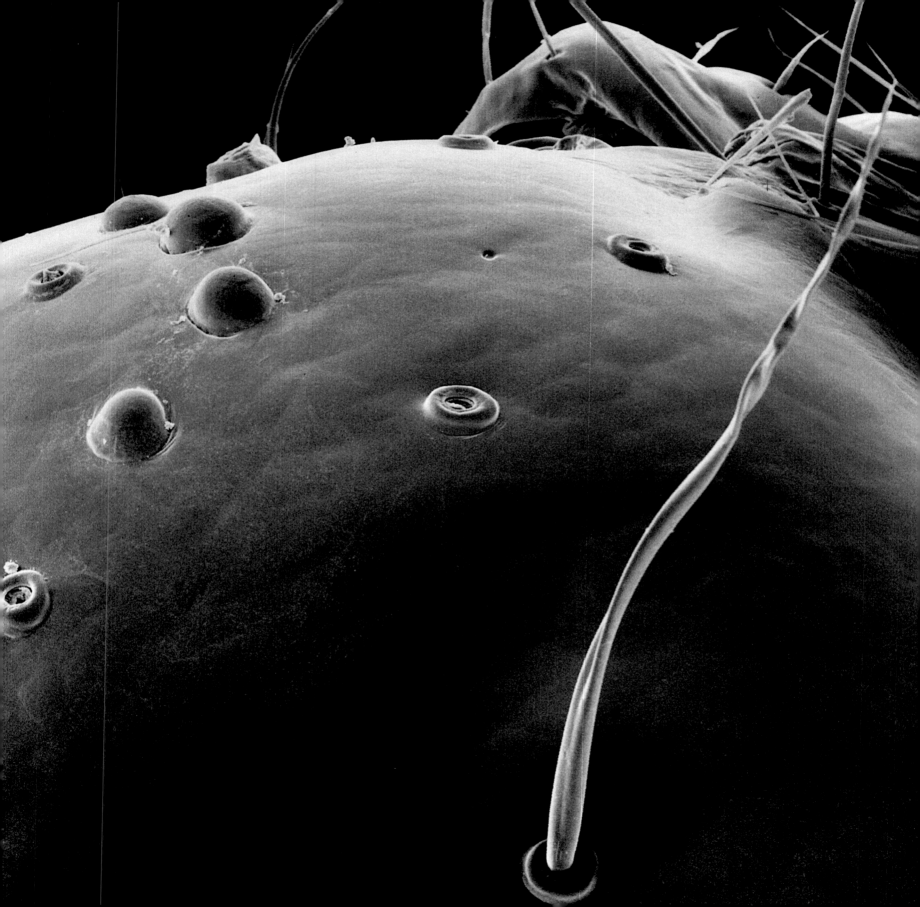

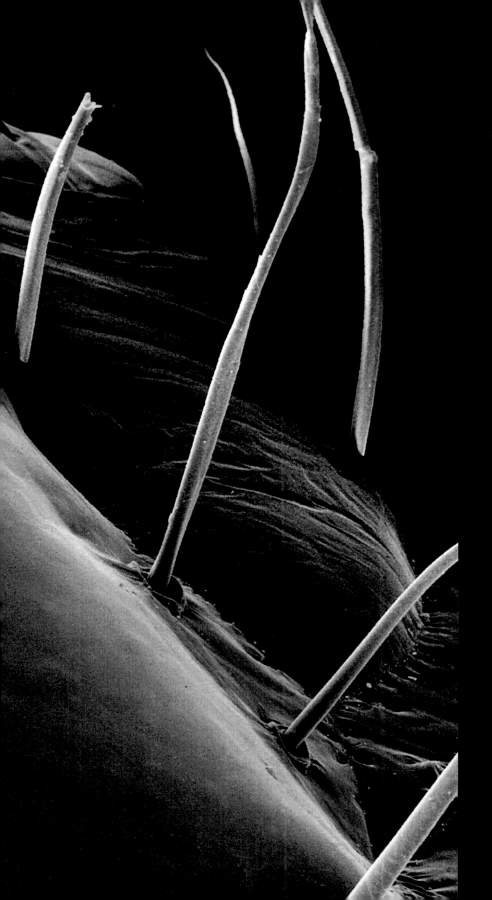

LIKE THE ASTRONAUTS, BUT MORE
MODESTLY, I DISCOVER EXTRATERRESTRIAL
CRATERS....I ESCAPE FROM THE VISIBLE,
JUST AS THEY ESCAPE THE ATMOSPHERE....
WE DRIFT IN OPPOSITE DIRECTIONS TO
THE ENDS OF OUR WORLD BORDERING
OTHER UNKNOWN UNIVERSES.

PLANET MARS
Caterpillar head

SILICON VALLEY

Interface of silicon crystals

My imagination is fired, my soul is like
Magellan's as I near unknown shores.
Who knows what I will discover there?

Easter Island
Details of maybug head and close-up

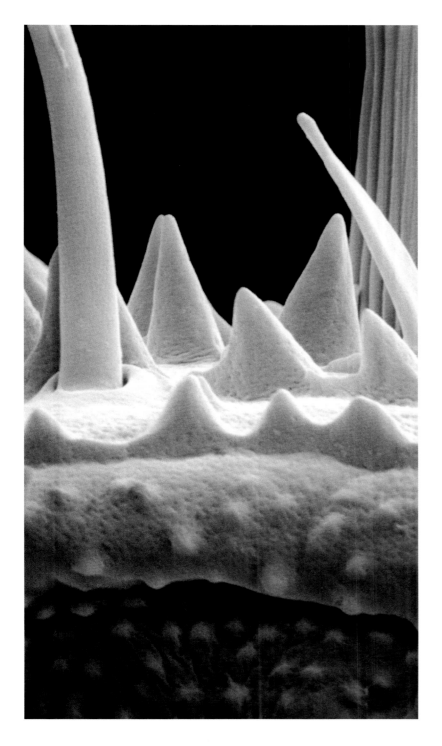 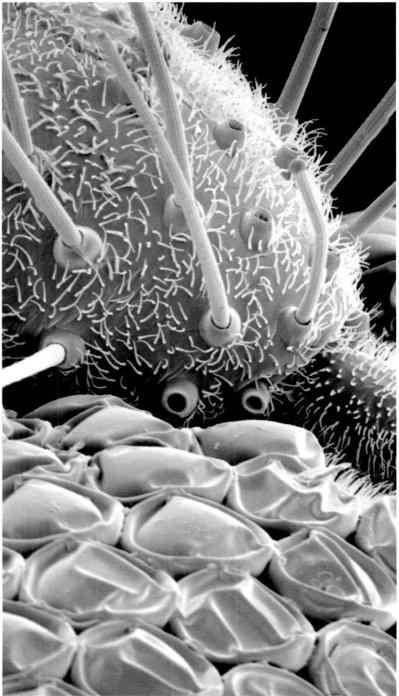

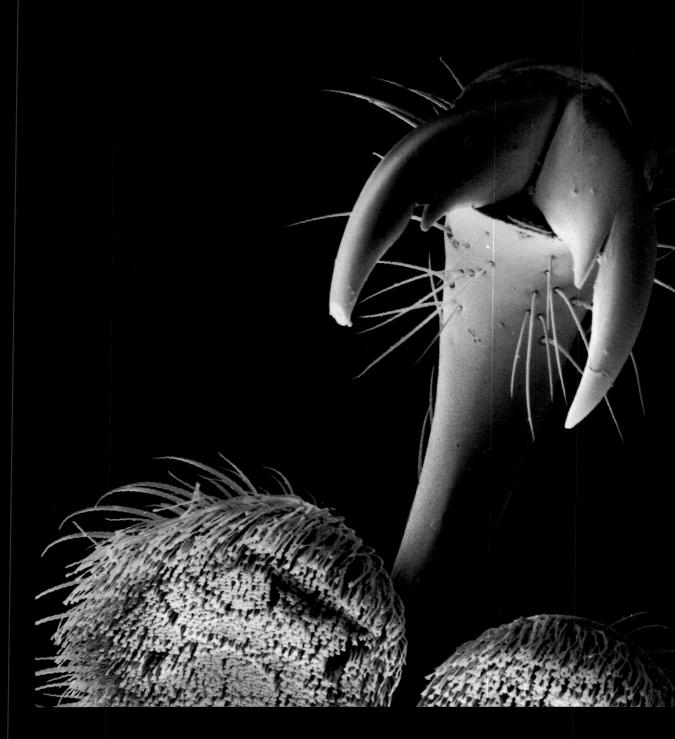

MENHIRS

Pad of beetle's foot and close-up

Cocktail
Fennel hair

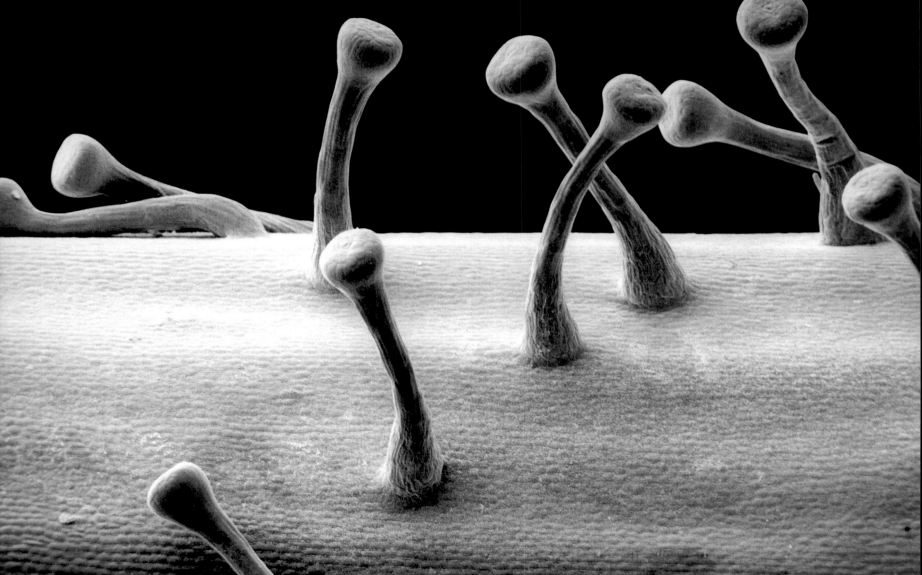

CHAPTER III

NATIVES OF THE MINUSCULE

UNDREAMED-OF TRIBES

THE SECRET LOCKED UP IN THE ARMOR

CAPTIVATING MASKS

Undreamed-of Tribes

CIVILIZATION HAS PERHAPS TAKEN REFUGE AMONG
SOME LITTLE TRIBE THAT HAS NOT YET BEEN DISCOVERED.
—CHARLES BAUDELAIRE

Suppose life were as developed in other galaxies as it is in ours and technology were sufficiently advanced to allow extraterrestrials to visit. What is to say that these ethnologists from space would necessarily be similar in size to us? After all, the greatest inhabitants of our planet, both in terms of number and in seniority, are insects! Why should living beings from another place not also be the size of an aphid? If this were so, their UFOs might be no more visible than grains of pollen floating in the breeze and they would not be in contact with the mountains we are. Insects, which have vastly populated the earth for some 250 million years, would have been the first earthlings they would have met.

Well before the first grunts were heard from primates, ant societies built cities with populations in the millions. Fearsome warriors, they hunt and store their goods, defend their cities, and capture slaves. Some cultivate mushrooms, others harvest aphids for milking. Bees, in their shining wax, architecturally complex palaces make honey cakes for their queen and nurse her larvae which they protect, at the risk of their own lives, with the poisonous sword protruding from their abdomens. Wasps perform microsurgery in order to paralyze their prey; dung beetles invent the wheel to better roll their sustenance. Clumps of grass shelter engineers, gravediggers, parasites, and even thieves. The most extravagant of our creators are far from imagining the exuberant character of the creatures that swarm at their feet. Exceptional and anonymous artists teem in our undergrowth: crickets are violin virtuosi, caterpillars weave the finest of embroideries, termites sculpt wood, and butterflies

paint eyes on their wings to scare birds. As Paul Valéry maliciously said, "God knows what metaphysics and geometry the invention of mirrors and glass was able to engender among flies."

If this "civilization" of insects bore witness to an "extraplanetary" landing, its customs must have fascinated the visitors, unless, of course, the latter were immediately devoured before having the time to introduce themselves.

It is true the voracious appetite of insects and their ability to escape our pink slippers has not endeared them to us. Yet, we have to admire their ecological success and it would be to our advantage to draw inspiration from their ingenuity. While it was only through great effort and much time that we invented the tools necessary for our development, nature equipped them in mass production with hooks, pincers, shears, scrapers, sickles, and spades, to say nothing of arming them with blades, har-

poons, and spears. Not content with carrying their tools for survival, they developed ways of seduction that would make the most ambitious of our Don Juans go green with envy. These minuscule Casanovas most certainly do not need a wigmaker to dress them up, nor do they need to powder their faces or spray on perfume. Upon reaching adulthood, they are adorned with delicate and shimmering fabrics, and as if by magic, leave traces of their irresistible love perfumes across the land. These experts of swooning also know how to serenade. Sounds of cymbals, harps, and flutes escape from their legs or their wings. The sun's rays aid and abet the lovemaking, glistening the bronze layers of the butterfly's wings, caressing them so as not to betray the camouflage. At night, some species of fireflies gather together to shimmer in unison in a great dance of phosphorescence and music. Light itself acquiesces to their loving.

The Secret Locked Up in the Armor

ANYONE WHO IS FEARFUL STUTTERS IN HIS SEEING.

—MALCOLM DE CHAZAL

Insects scoff at us. Their crunching and whistling, their clicking and buzzing bother us. Surreptitiously, they take advantage of their smallness to interfere in our lives. Relentless, they torment us. They harass us, try our patience and sometimes push us over the edge. Bites, toxic wounds, fever—their overwhelming ardor has no bounds and we are only spared when sweeter, more available flesh is found. I have a few stinging memories: the burn of a giant Brazilian caterpillar that paralyzed my arm for several hours and turned it dark blue for months; a mosquito from Tanzania caused me to lose more than forty pounds and had me bedridden for several long weeks; a very hairy trap-door spider that hung from the ceiling of my tent in the African bush when I was ten still gives me nightmares. It is precisely because these multilegged creatures always scared me that I wanted to observe them closer up. The first time that I magnified an insect was when I was doing zoology lab work. I had taken the animal from the jar of formaldehyde where it had been floating for years. Then I put it under the weak lens of my student micro-scope. I must have somehow squeezed the fluid-bloated abdomen, because the cricket frenetically began to move its legs and mandibles, staring at me with its oozing eyes. I let out a cry that terrified the whole laboratory and set the animal in flight one final time, along with its jar. Bringing insects to our scale sends us into a universe from another time, there where our ancestral fears are concentrated. These six-legged monsters seem to spring up from an ancient mythology filled with menacing visions. Harpies, dragons, Minotaurs, sentries, and centaurs hide under stones and watch us from behind the bark of a tree. On every stem, helmeted knights shine their coppery breastplates and watch us closely with their thousands of eyes. From the top of a lavender blossom, as if from some intergalactic war, hunters with dart-decorated wings are poised, ready to swoop down on their prey. In The Garden of Earthly Delights, Hieronymus Bosch painted creatures no stranger than those naturally populating our fields.

We spend vast sums on giant radar antennae that enable us to listen to the stars. Perhaps we should first learn how to communicate with our neighbors living in the grass. Who knows what wisdom the beetle worshipped by the Egyptians could pass down to us? My past experiences have not endeared me to spiders, flies, or crickets, but my unconditional love for nature has made me look deeper. I did have to muster up some courage the first time. A small spider had ventured right onto the dashboard of my car. Soon, it was climbing onto the steering wheel and almost made me drive into a ditch. I caught it, chloroformed it, and stuck it under the electron microscope. Magnified, it turned into a terrifying tank with eight menacing eyes planted around a turret. It was Easter and the labs were empty. The crackling and gurgling that exuded from the tubes of my machine became amplified and all of a sudden, I felt surrounded. A gladiator with eight hairy legs challenged me in the amphitheater of my laboratory and prepared to throw his trident and silk net at me. In broad daylight and perfectly sober, I was experiencing the nightmare of delirium tremens. Having lost all scientific reasoning, I quickly turned off the machine and beat a retreat.

Our imagination often scares us more than the visible. It took me three weeks to dare to restart this experiment. Perseverance is key, so I took out the same spider from its jar and finally got to the next step with unexpected success. Before my stupefied eyes, the microscope had found the beauty behind the beast. A princess's sincere kiss is sometimes all that is needed to transform a frog into a Prince Charming. The caress of my electrons made the fairy tale come true. Past a certain point of magnification, all portraits become landscapes. The marvels on my screen now inspired only gentleness and poetry. A kindly oasis in the desert of fear. I was very moved. The microscope suddenly revealed the beast's secret to me: "I was beautiful, but you did not look at me close enough."

Beauty exists everywhere in nature, it is intrinsic to life. It was my fault for not having noticed it earlier, not the spider's fault! I felt like we had made a pact, like I had signed a peace treaty with all living beings, no matter how repugnant they seemed to be. So many other conflicts could be avoided in this way if we all changed our way of seeing, if we went beyond the mask to find the essential.

Captivating Masks

APPEARANCES ARE BEAUTIFUL IN THEIR MOMENTARY TRUTH.

—OCTAVIO PAZ

Masks take advantage of our vision. Immediately, we assign an identity and specific attributes to those who wear one. The orchid disguises itself as a female bee so as to seduce its pollinators, an actor in No theater covers his face in order to captivate his audience, a wig reinforces a judge's authority, makeup enhances a woman's beauty, tattoos make the warrior more fierce. By disguising themselves, sorcerers and shamans become messengers from the beyond. They claim to have contact with other universes that, without their "talent," would remain inaccessible. The genetics researcher and the astronaut are special in our eyes—in their protective suits, they penetrate dangerous areas and above all, bring back knowledge that can enrich humanity. Masks are intriguing to us precisely because they are more than simply protection. They seem to have magical powers, as if our way of seeing transformed them. As if we imposed our mental images onto them. At my exhibitions, I am continually amazed by how differently viewers react to my insect figures. A single portrait of a wood bug has been seen as both an African and an Aztec mask, as an Inuit fetish or an eccentric scientist, and even as an alien. Eskimo totems depict figures that are half human and half fox, crow, or wolf. The sculptor reminding man that he and animals are brothers, blood relations. In his fruit-man and flower-woman portraits, Arcimboldo suggested something similar—that people were related to plant life. In the same way, a viewer coming face

to face with giant insects painted black and white by the elec-
trons believes them to have a secret partnership with another
world and likens them to specters capable of freely commuting
between two worlds, only one of which is visible to him. He
gives it an enigmatic personality and even if he no longer
believes in the prince behind the toad, he seeks the infinite
behind the ephemeral, the eternal behind the caterpillar.

After all, the caterpillar has the real and very symbolic privilege
of being reborn as the butterfly known as the sphinx. Perhaps it
holds the secrets of immortality. Does it not also search for the
elixir of life when it gorges on sap?

THERE IS NO ANIMAL THAT DOESN'T REFLECT THE INFINITE.

—VICTOR HUGO

DOCTOR HONORIS CAUSA

Portrait of wood bug

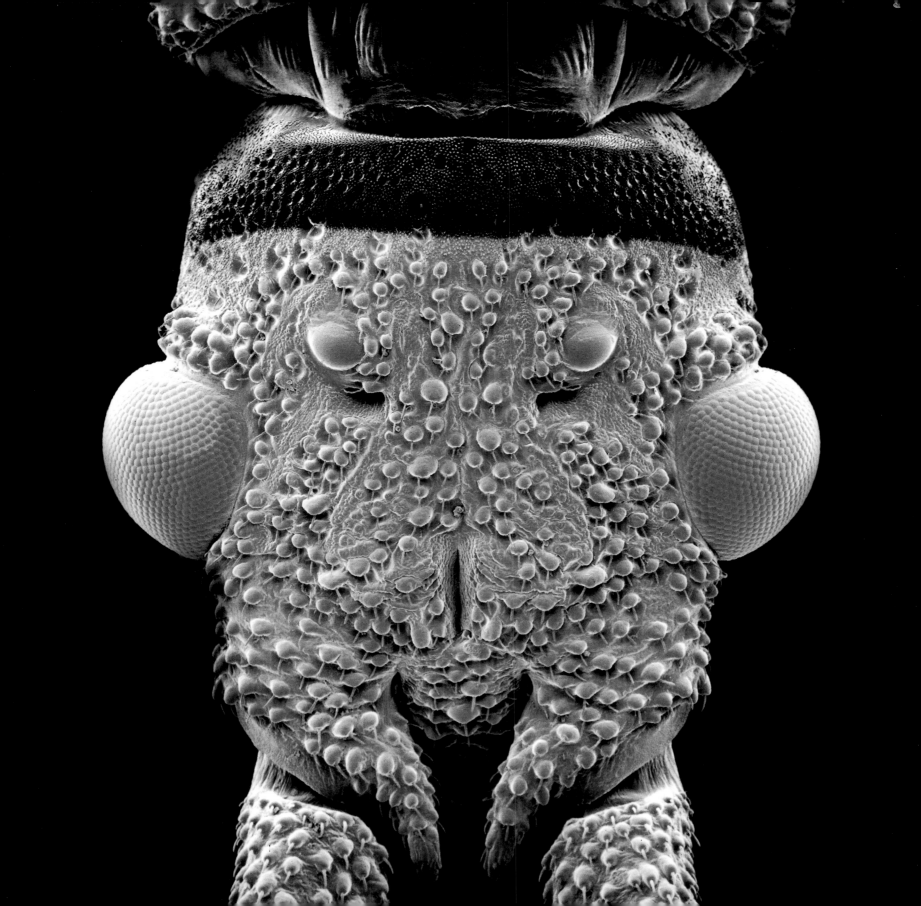

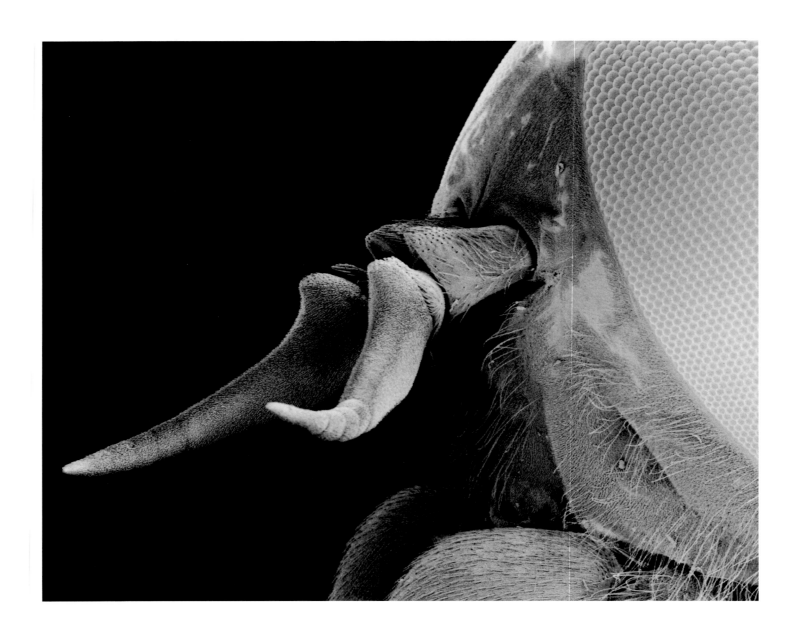

MINOTAUR

African horsefly

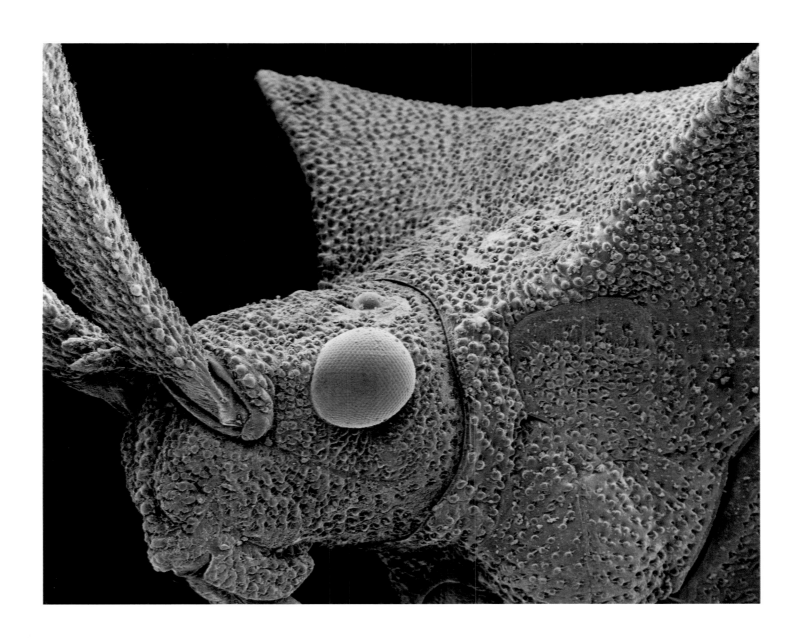

TRICERATOPS

Wood bug

THE CENTAUR

Portrait of ant

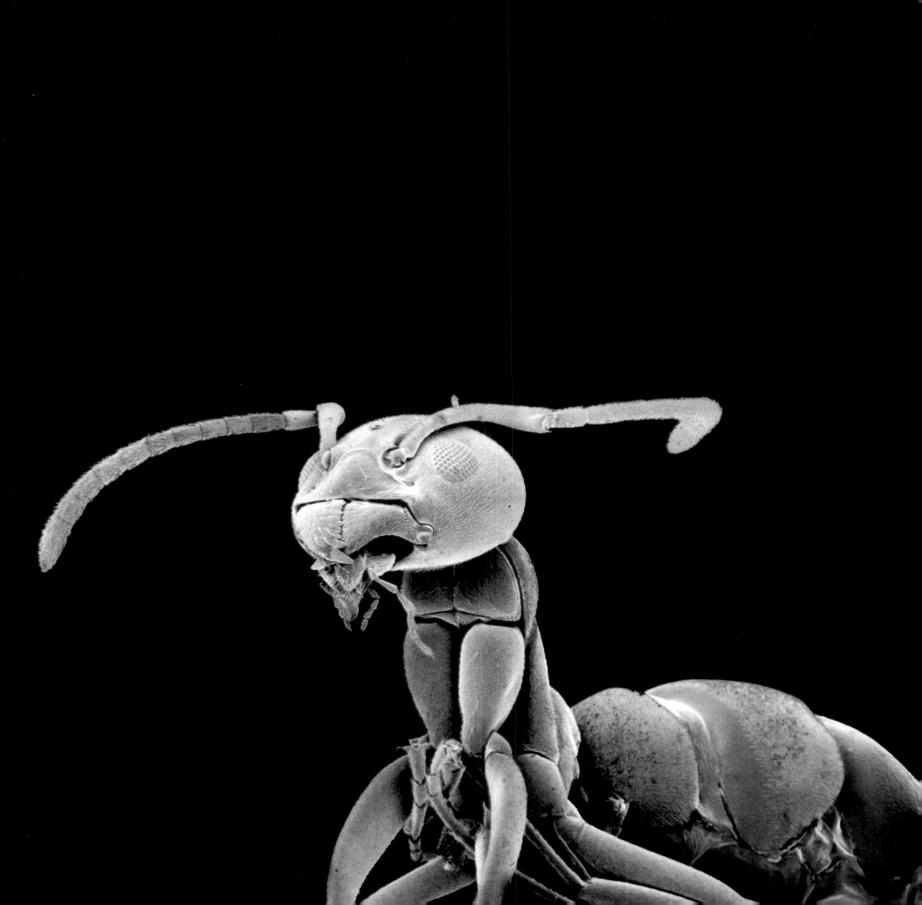

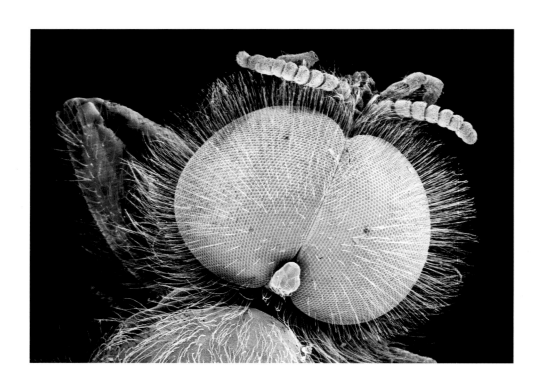

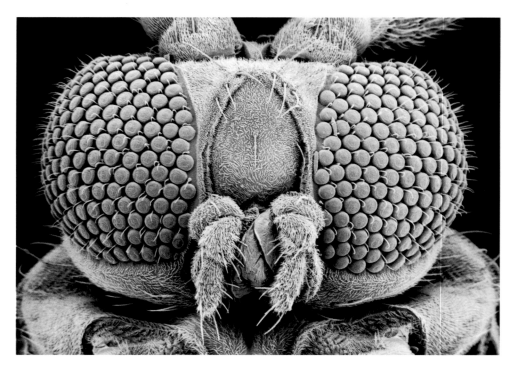

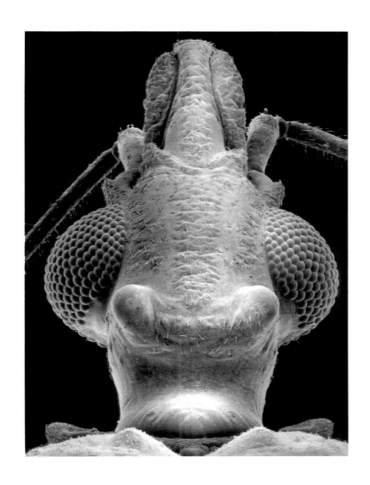 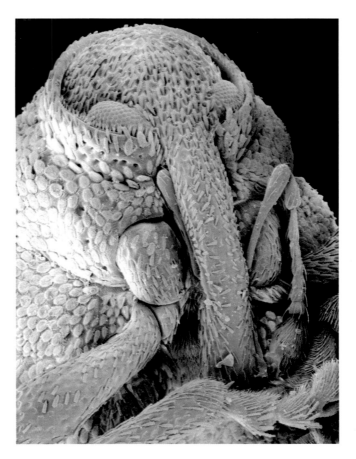

IN The Garden of Earthly Delights, HIERONYMUS BOSCH PAINTED CREATURES NO STRANGER
THAN THOSE NATURALLY POPULATING OUR FIELDS.

PORTRAITS

Various insects

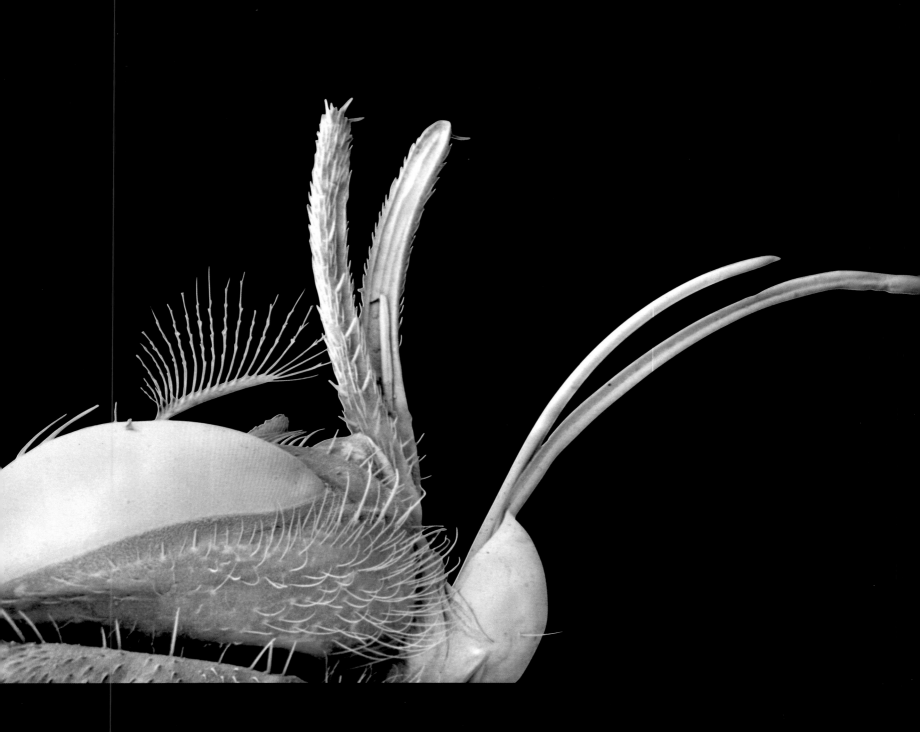

LADY TSETSE

Tsetse fly

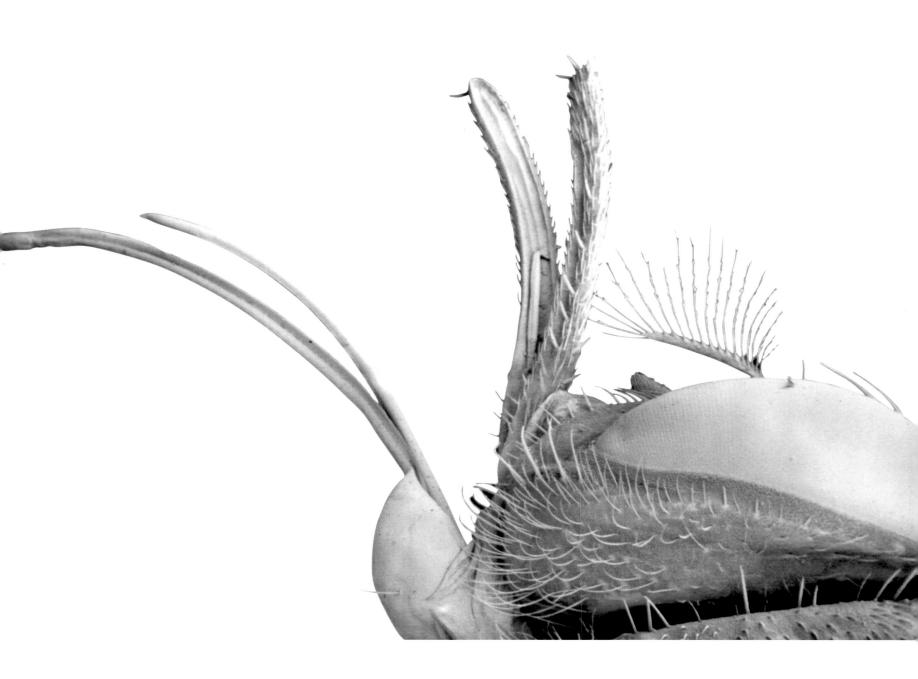

WHAT DOES IT MATTER TO THE FIRMAMENT

IF WE ARE FLY OR RATHER ELEPHANT.

—JEAN DE LA FONTAINE

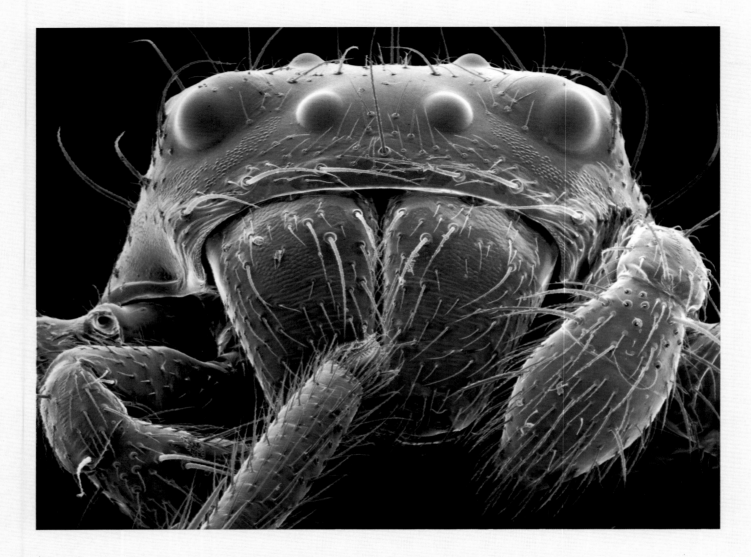

A GLADIATOR WITH EIGHT HAIRY LEGS CHALLENGED ME IN THE AMPHITHEATER

OF MY LABORATORY AND PREPARED TO THROW HIS TRIDENT OR SILK NET AT ME.

THE MICROSCOPE SUDDENLY REVEALED THE BEAST'S SECRET TO ME: "I WAS BEAUTIFUL,

BUT YOU DID NOT LOOK AT ME CLOSE ENOUGH."

GLADIATOR

Spider

ZOOLOGICAL

GARDENS

Close-up of spider skin

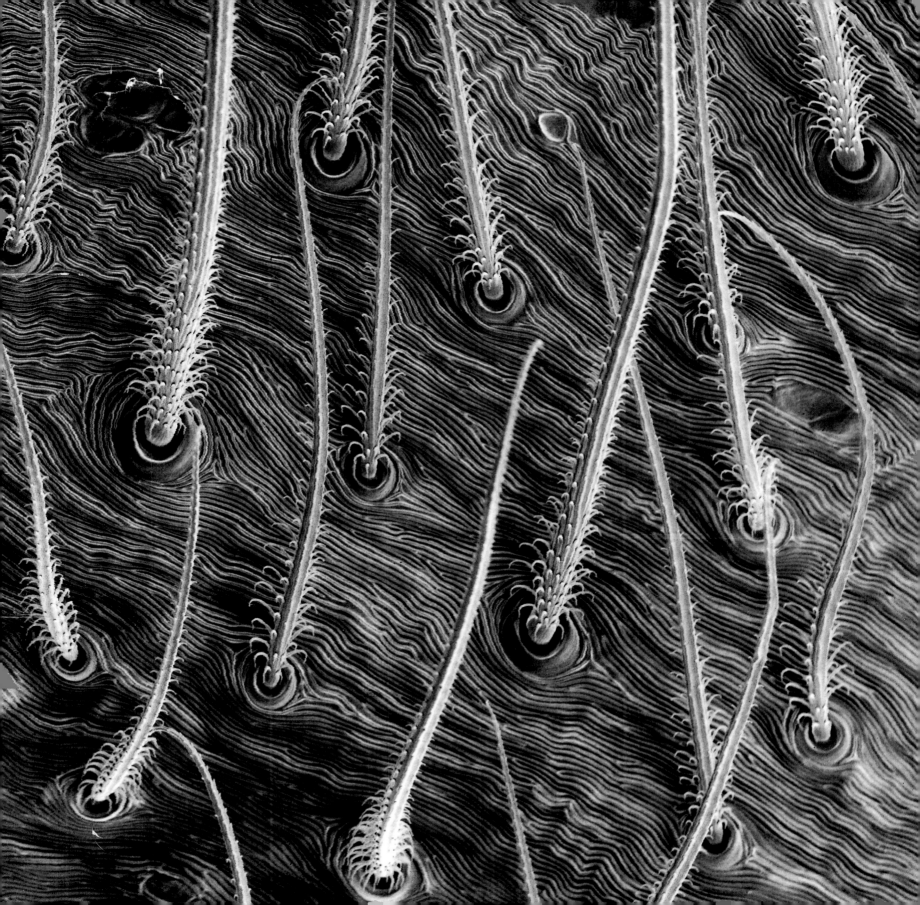

Takeoff

Tip of a gnat's leg

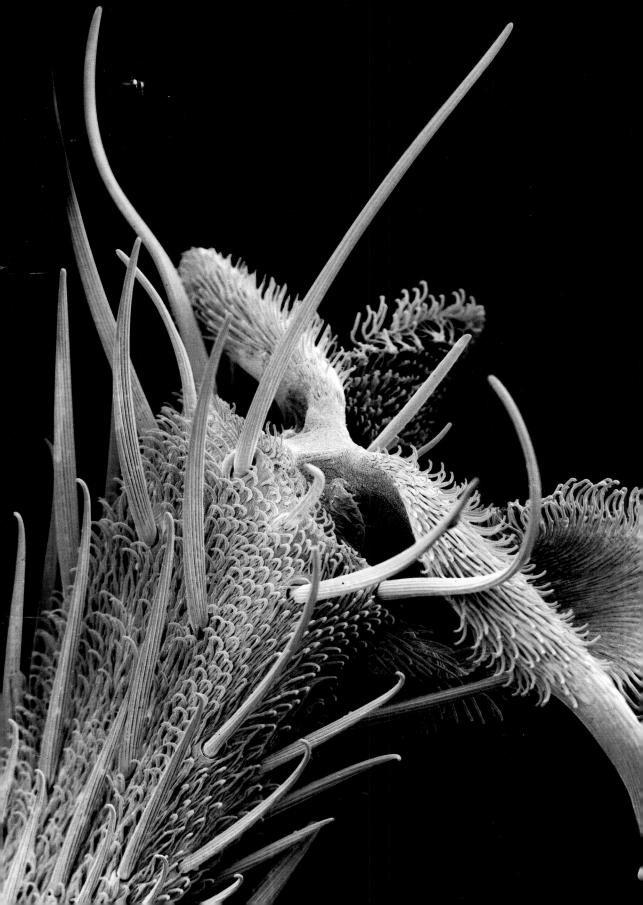

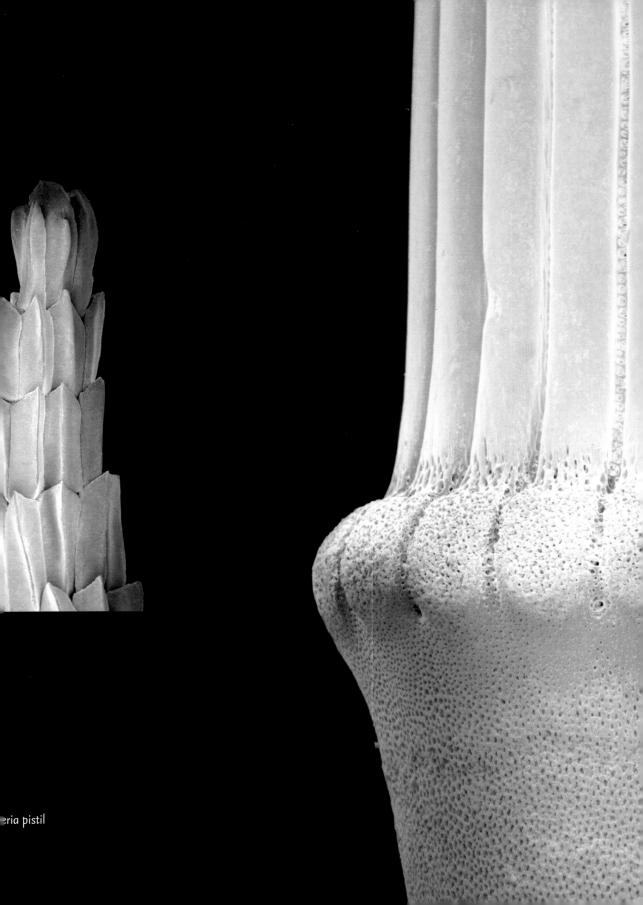

eria pistil

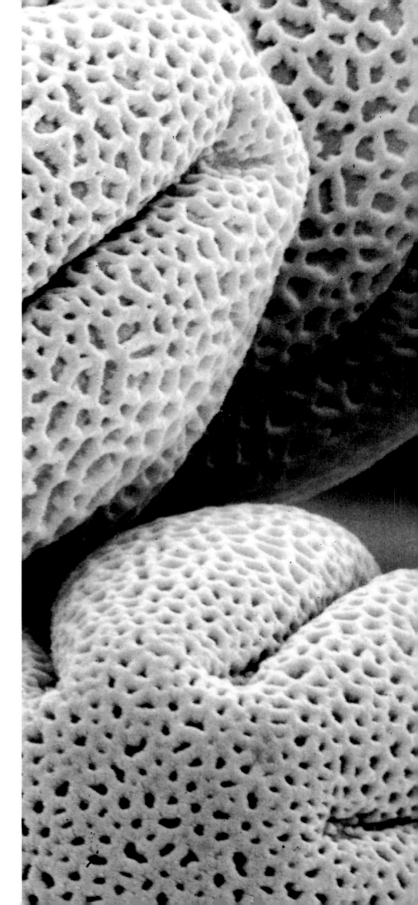

WHY SHOULD LIVING BEINGS FROM ANOTHER
PLACE NOT ALSO BE THE SIZE OF AN APHID?
IF THIS WERE SO, THEIR UFOs MIGHT BE NO
MORE VISIBLE THAN GRAINS OF POLLEN FLOATING
IN THE BREEZE...

MINI-UFO
Wild cowslip pollen

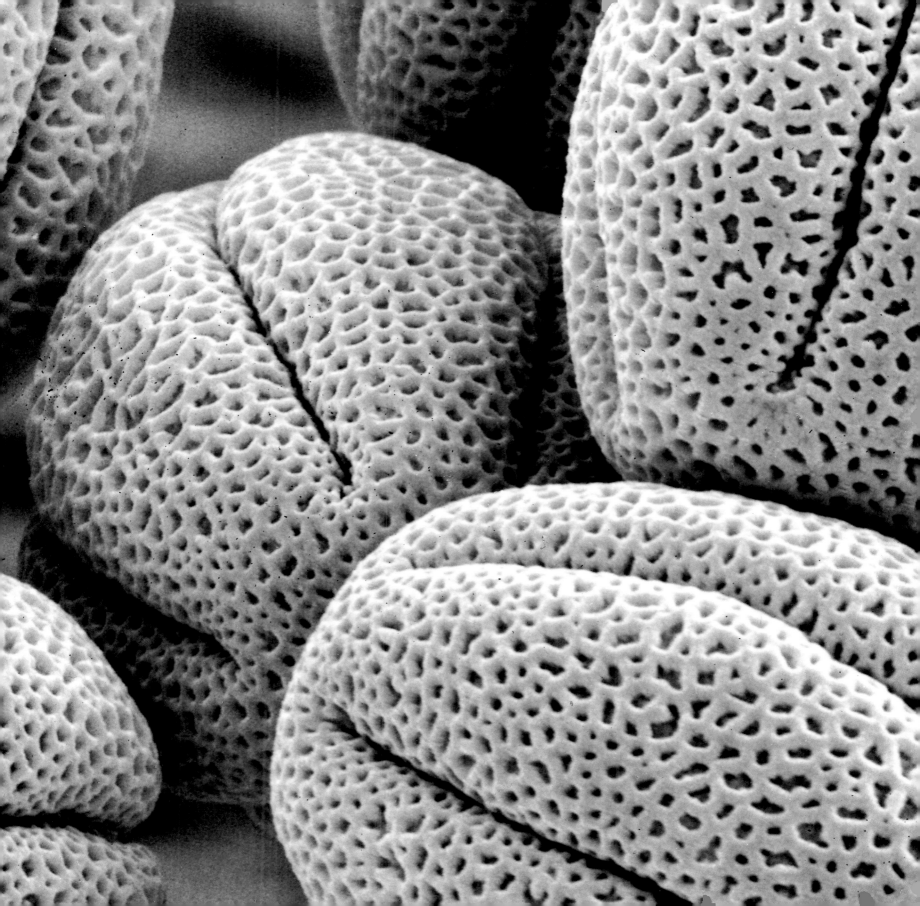

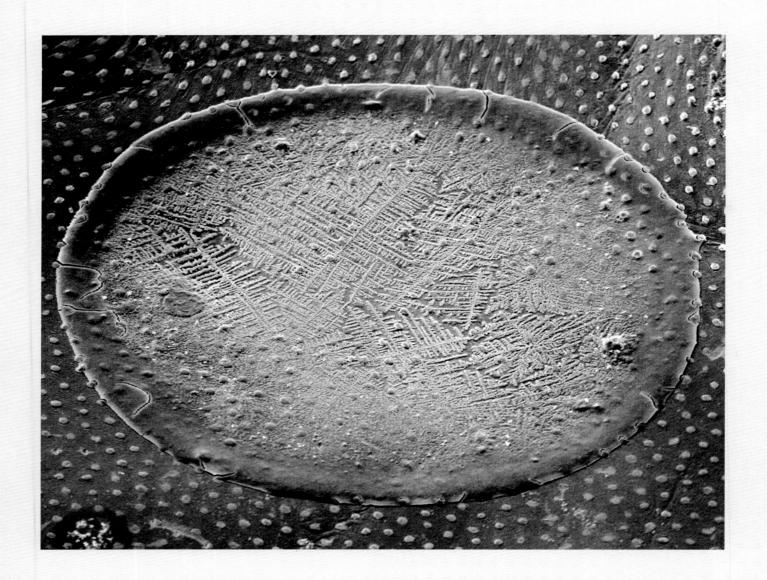

SPACE CITY

Unidentified structure on insect skin

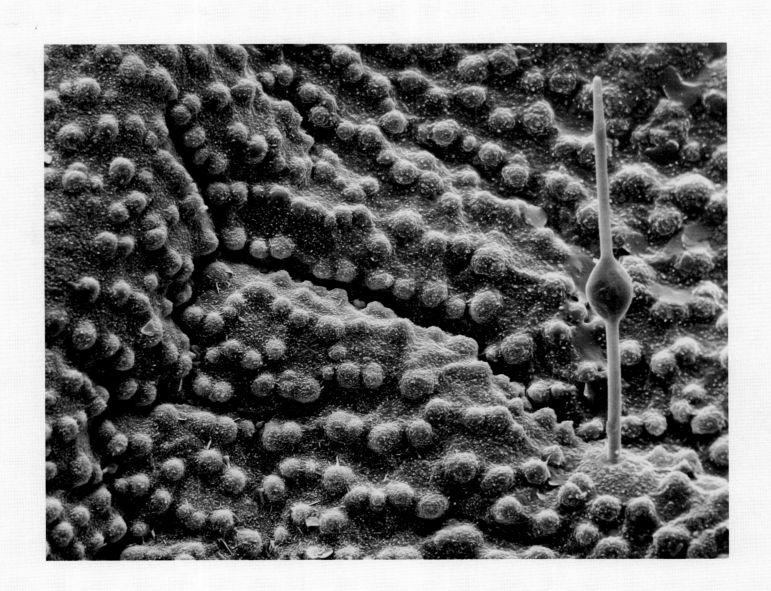

APOLLO 2001

Hair on head of African eland parasite

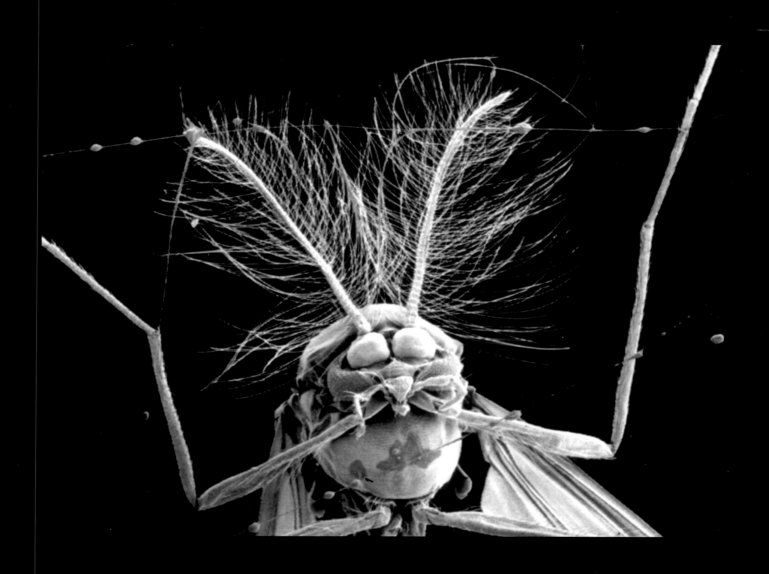

SILK TRAP

Gnat's eye caught in spider's web (close-up)

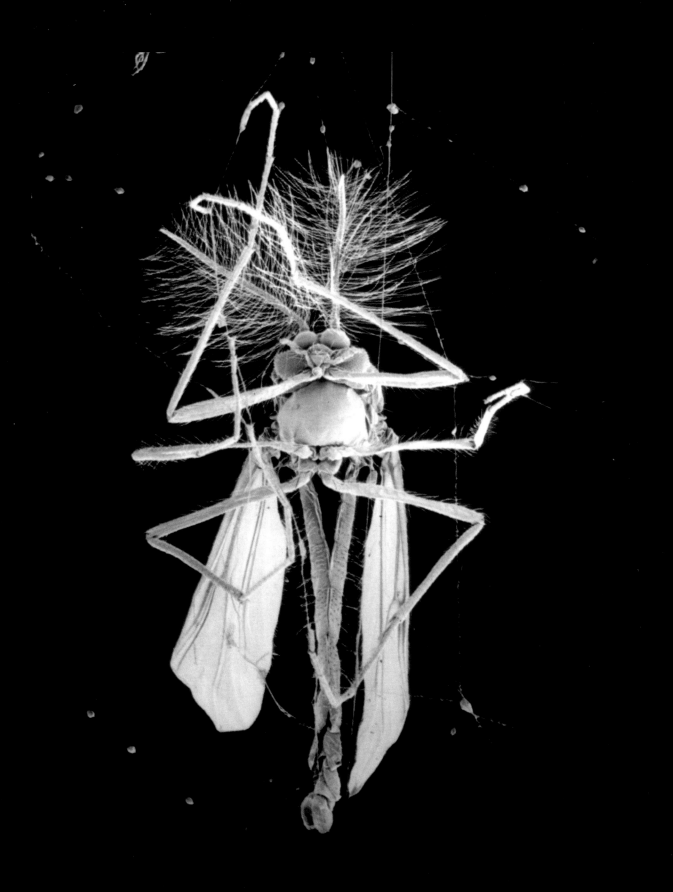

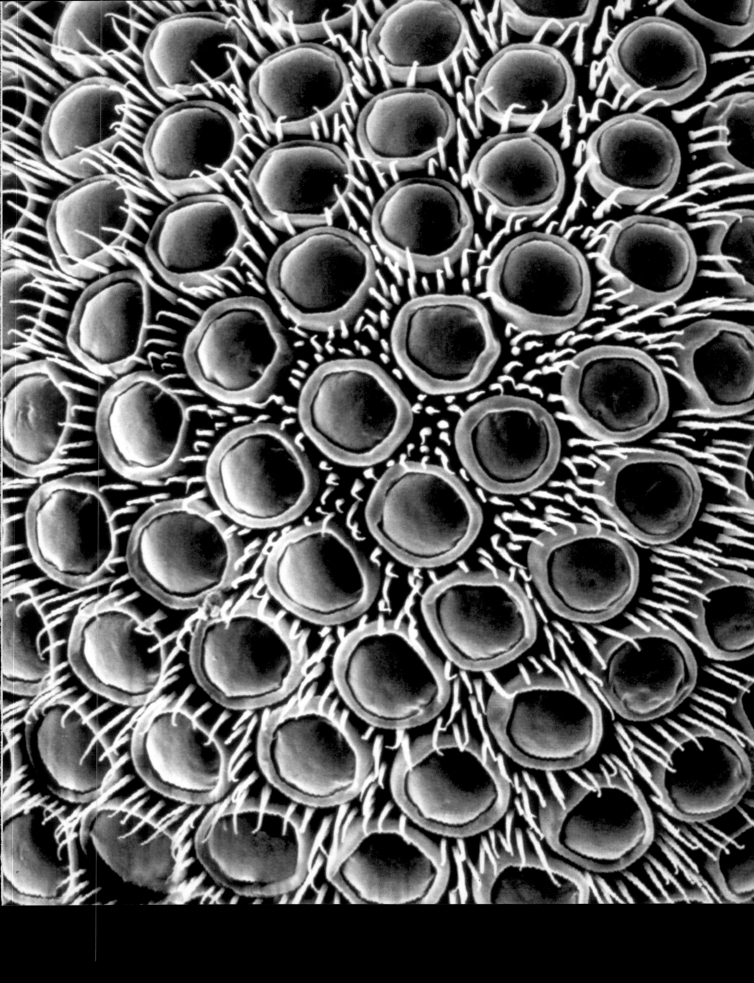

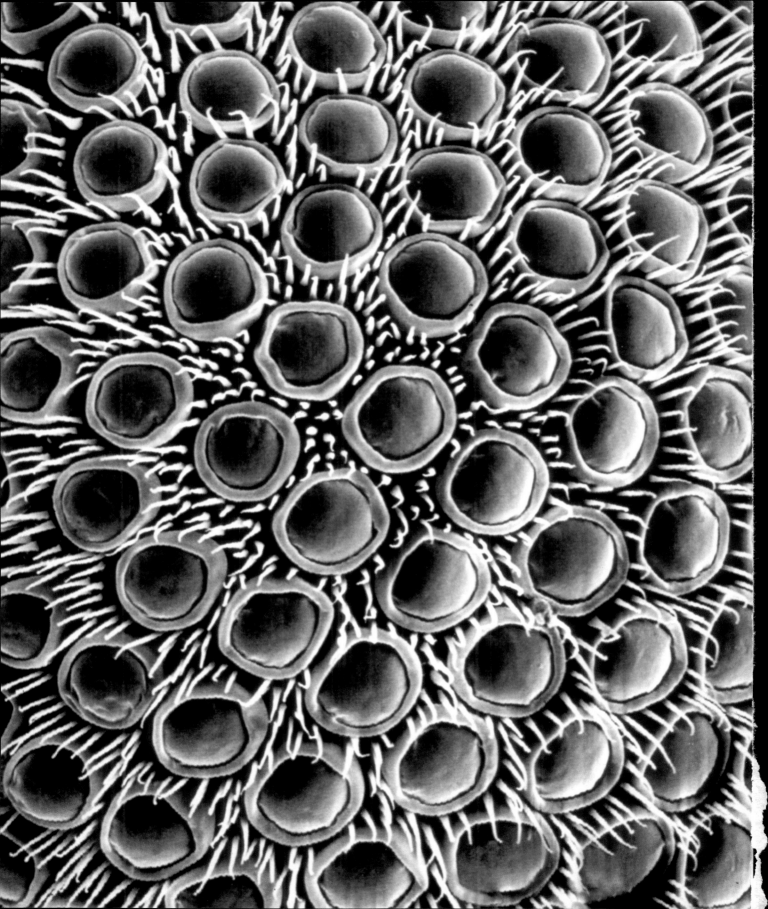

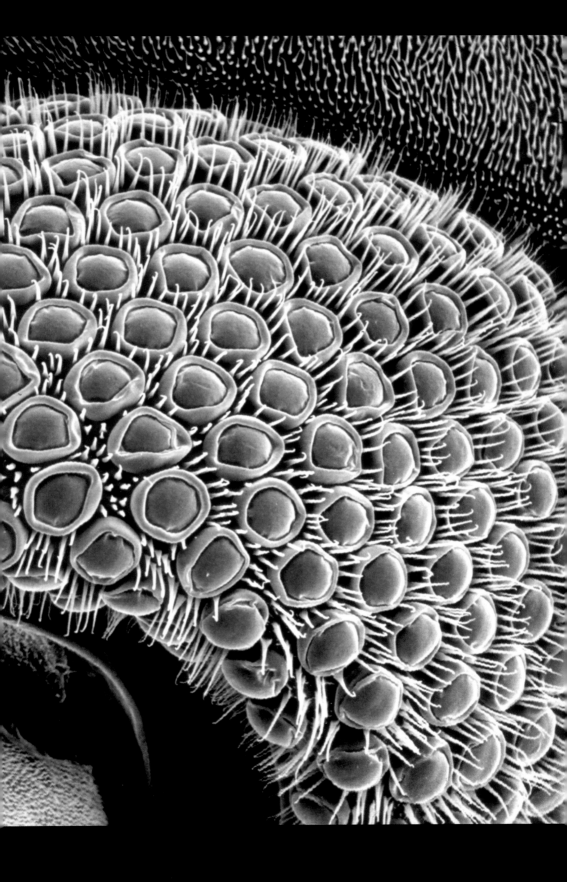

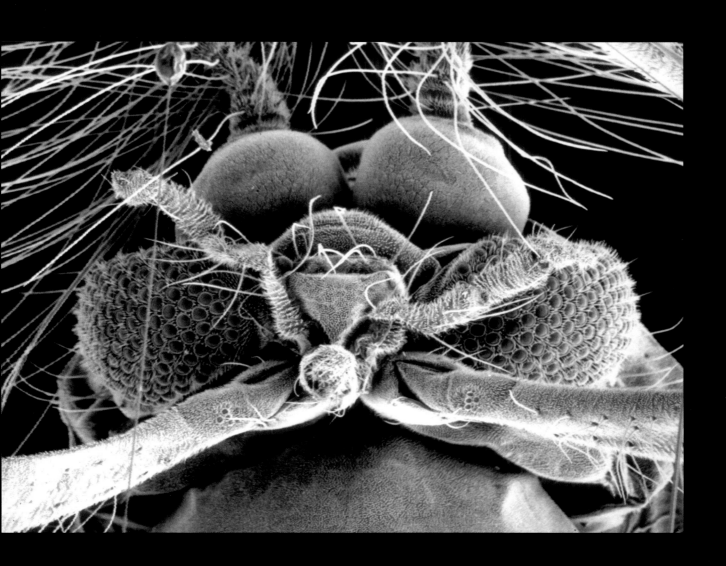

CHAPTER IV

BEAUTY UNVEILED

Embroideries and Shapes of the Living

In nature, a kind of art is at work.

—Aristotle

From galactic spirals to the elegantly shaped DNA helix and the snail's humble shell, nature's fantastic creations are captivating. The admiration we have for them is expressed in these simple words: "Nothing is more beautiful than nature." This beauty is found on all scales right down to the invisible. Bursting forth from the microscope, a shower of electrons clears the fog that keeps Mother Nature's least-known masterpieces from our eyes. On view in this living museum are six-armed Venuses, victories with transparent wings sculpted in chitin, caryatids covered in pollen, pistils in colonnades, pyramids of spores, bronzes engraved with vivid symbols, as well as flowing hieroglyphics. What mysterious law of nature has brought them together?

I now know that I do not derive pleasure merely from perfect geometry, but also from the eternal enigma that it reflects. What does the world mean? From where comes the harmony that seeps into every bit of life?

They say matter is but "void transgressed by light." Perhaps a transcendent harmony gives it form, transmuting it into its light and coherent structures where nothing is insignificant or useless? Different from human inventions, nature always succeeds in reconciling beauty and usefulness. Is it extravagant, ever ready to treat itself to the finest? The jewels that adorn those cellular landscapes are neither superfluous nor arranged at random. They obey mysterious architectural requirements that escape our understanding. There is only the appearance of anarchy. Behind chaos exists a hidden order. Does it come from the secret intentions of a secret builder? Like Dante's

Beatrice, I slide into the depths of a rose, for it is true that when you near the heart, you can learn its secrets. I gaze upon the exquisite embroideries that were donned by the "rose who this morning had opened its crimson robe to the sun." As the poet's eye needs no instrument, Ronsard was able to imagine the perfection, outstepping scientific precision by several centuries. From the top of my microscope, unfortunately, I can only see the robe in black and white, as if from this not-too-mighty height, I were atop a mountain and small clouds were casting a veil over the landscape. No one can be certain of a petal's true color. Pink is but a mix of colors, and whatever Ronsard's view, "the folds of its purple robe" which I fly over from the height of a few microns, are perhaps blue, green, or yellow! Like the rose so dear to the Little Prince, it is unique and resembles no other. The flower will keep its truth for a long time to come, as well it should.

"In a rose's memory, we never saw a gardener die," as Jacques Prévert wrote. Thanks to telescopes, we can witness the death of a star—even a few million years after the fact. We also know how to retrieve signals that teach us about the birth of the universe. The initial big bang and its counterpart in time, the final big crunch, have a point in common: they are both without definition. It is between these two instants of eternity that all forms develop, each original. Physicists tell us that forms evolve according to the space around them and thus, crystals do not grow in weightlessness as they do on earth. For the architect of the universe, gravity, electrical and magnetic forces, surface tension, and nuclear power are tools of greatly different powers. He uses them judiciously to assemble structures and give shape to forms, from nebulae to atoms. Along with a capacity for invention, he can also keep secret nature's modes of efficiency. One, the "golden section," is found in most plants, both

in the birth canopy of leaves and in the arrangement of seeds. This formation enables the spirals of leaves to intertwine harmoniously and the seeds to be well concentrated in the fruit. Note the allusion in the beautiful rise of an ibex horn and in the elegant curves of the nautilus. It is also he (is it by chance?) who inspired the architect of the Parthenon or who brought about the rose windows in our cathedrals.

Like a sculptor with clay, the universe sculpts, kneading, hollowing, rounding the forms, and then removing the unnecessary lumps. It will, of course, respond to outside pressures governing it, but all transpires as if it were giving in to its own impressions and impulses! We presume it will respect the laws of physics, but it breaks them whenever possible, forcing every generation to produce a new Einstein who will contradict his elders. As with all artists, it finds nothing more boring than academic rules. Using marginal and preposterous ideas, it avoids dull uniformity. It gives legs to fish, fins to mammals. It turns an insect into a branch, seaweed into a star. Everywhere it creates, forever, it will spread beauty, transmit a smile, and send monotony into the silence of infinite space.

Why Is the Invisible Beautiful?

THE HARMONY OF THE INVISIBLE, MORE BEAUTIFUL THAN
THE HARMONY OF THE VISIBLE. NATURE LIKES TO HIDE.
—HERACLEITUS

Beauty is as powerful as a volcano, a private volcano that sets the heart ablaze and makes it race until stirred. It adds sizzle to our daily lives and burns away monotony. It rises abruptly, ephemerally. It is not predictable. He whose lava burns is carried into another universe from which he returns illuminated, transformed.

This emotional outpouring corresponds to a sixth sense, the most beautiful of them all, but it does not appear on command. With a light caress, we are able to stimulate our sensitivity to touch and with a mere mouthful, we excite our sense of smell along with our taste buds. Without striving to attain the "nose," or the "absolute" ear, we attempt to develop one sense over another. But our sense of beauty is beyond our will. It always

catches us unprepared and magnifies tenfold all other sensations. We believe that we are sharpening our sense of beauty by contemplating natural splendor, but in truth, no apprenticeship is required. Beauty is a sensation that suddenly emerges from deep within, subjugating all other senses to its despotic law, grabbing hold of our mind and disconnecting our neurons. This internal tumult then quiets down and pleasure hormones fill our body, harmony replacing chaos. Gradually, along with a feeling of cosmic peace that no other sense can pass down to us, order is restored.

This sense of beauty is not the sole prerogative of humanity. Animals also possess it. Peacocks spread their tails in front of a mirror and admire themselves. Lions know the majesty of their mane, stags flaunt their antlers. Whether an Andes condor or a

garden slug, all animals make themselves beautiful in order to reproduce. Even a toad will don its love markings to cast a spell over its ladylove! The entire plant kingdom obeys the magical laws of love's aesthetics. A flower may wilt right after being pollinated because it no longer needs to seduce the insect.

Beauty is universal, from the humble worm buried in mud to the whorls of the galaxies. Of course, not all observers experience it in the same way. Consider, for example, the aesthetic perceptions of the Papuan and the New Yorker. Or those of the philosopher, the artist, the scientist. In beauty, a mystic finds a prayer for his faith and the artist, nectar to nurture his sensibility. A scientist, who rarely looks at something without asking questions, will interpret his visual emotions through the logic of his intelligence and will submit them to analysis. These three different methodologies, each in its own way, aim to find meaning in the universe. But the perceptions also have a point in common—they remove us from daily life and give us a feeling of metaphysical joy. Could light vibrations emanating from beauty be more intense? The indifferent eye, unable to grasp them, would remain complacent. These waves of beauty might have the power to ignite a sacred fire that fills us with love, a clear mind and faith. The wonderment of the child reemerges within us, allowing us to enter another dimension from which we return enriched and filled with a new trust. The physicist Paul Dirac wrote, "It seems that if one works with a care for having beauty in his equations, and if the intuition he has is sound, he is on a straight path to progress."

More than anyone, the scientist wants proof; watching like a hawk, he seeks clues and searches for explanations. The biologist knows that every question calls for an answer. Undoubtedly an answer cannot always be known, but when it is discovered, it engenders new questions. This is how research progresses, step by step, in a series of whys and becauses. Ever since Darwin, whenever we seek the primary cause, we systematically base research upon the sole criterion of the usefulness of the species. Could there not be a scientific explanation for *beauty in biology*? For many, this is a preposterous question, yet, how can we justify the omnipresence of beauty in nature? Could its raison d'être be purely functional? A convincing illustration might be seen in the splendid purity of the dolphin's hydrodynamic forms. Can beauty be a sexual attribute as well? This would justify the bright red of a male ostrich's beak during the mating season, the bearing of a stag in rut, and to a certain extent, the attention a woman pays to her appearance. But what can be said about beauty that is found in hidden regions where by *nature it cannot be seen?* For whom is the beauty of those unfathomable fish that live in the depths of the ocean where no light reaches? Why is the skin of this wood bug as beautiful as lace painted by Vermeer when the compound eyes of its fellow creatures are designed to detect movement and cannot even perceive the beauty? If the infinite beauty of the infinitely small is gratuitous, then the invisible is perhaps the domain of "absolute" beauty…one that need not be observed.

Chance or Beauty?

Why, if beauty is universal, would it not have played a role in evolution? Yet, not one university has proposed to conduct a scientific study. Differing from the Darwinists, I do not believe that life can be reduced solely to the competition between species that are more or less adapted. It is time to bring a few "mutations" to this theory that is significantly more stable than the "variations" on which it is based. Symbiosis, cooperation, and interdependence also deserve to be acknowledged as engines of evolution. However, more than chance, they obey *beauty*.

Beauty is indeed a powerful force and a law of life. A billion years ago, the first "organized" living beings were born from a combination of numerous individual cells that joined forces and combined their abilities to meld into a new being from which emerged new talents that until then were unknown. These original qualities gradually favored the adaptation of the new organism. Forms of life that were progressively more sophisticated developed, and natural selection eliminated those less able. If there is strength in unity, it is indeed innovation that maintains it. Darwin, the youngest son of an Anglican pastor, before establishing himself as a naturalist of genius proportions, experienced the rivalries within his own family, as he later would the secret tensions in his parish and those more public between individuals in his village. His acute observations of nature would always retain this idea of competition. Struggle, conflict, and above all, survival are the weapons of Darwinian strategy. In the context of England as a colonizer, and in the throes of the Industrial Revolution, the weak were held in contempt and Darwin eased the conscience of the strong. I refuse to reduce life to the principles of war. Einstein said, "God is subtle but not malicious!" No, even if it is true that life, the eternal pioneer, likes border disputes, it cannot be reduced to a factory managed by military leaders who would manufacture "weakness" to fill the ranks.

Life is above all an artist who, in keeping with creative desire, takes the time to invent. Over millions of years, it has created union, symbiosis, cohabitation, and interdependence, and for weapons, it has provided love and beauty.

It is high time we bestow upon science more femininity, so that we finally recognize that, within nature, there is a form of cellular affinity and attraction. Life's favorite assistant is not chance. More than the risks of variation, the allies that it cherishes are bonds, coupling, and the union that precedes all birth. The universe has been pairing electrons within atoms since their inception. There are duos in every fundamental stage of the living. Is not DNA itself, with its paired chromosomes, an alliance of two complementary chains that in addition to the close bond of their links, interlace into a double helix suggesting a ritual between two serpents in love?

The first bacterium that *dared* to unite with another instead of killing it and absorbing it did more for the evolution of the species than all mutations in the world. I like to think that a certain form of beauty, even archaic, played a role in this primordial affinity. Symbiosis is a sacred bond that unites often profoundly different beings. Despite Darwin's views, life, like the woman who bears it, will always prefer marriage to war.

LIKE DANTE'S BEATRICE, I SLIDE INTO THE PRIVACY OF A ROSE, FOR IT

IS TRUE THAT WHEN YOU NEAR THE HEART, YOU CAN LEARN ITS SECRETS...

IN THE INTIMACY OF A ROSE

Respiratory cell of rose stamen

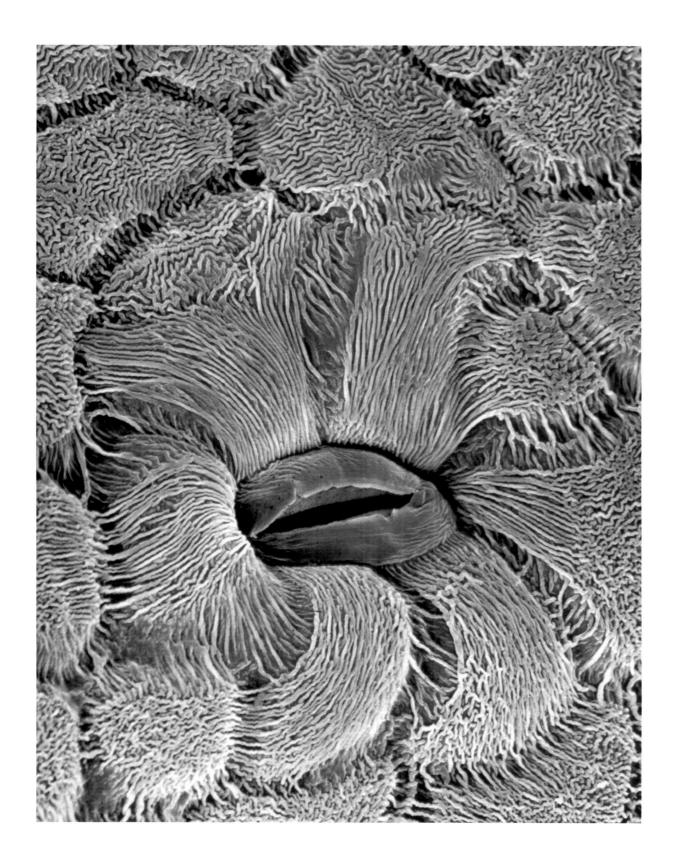

THE ARABIAN NIGHTS

Birth of ivy bud

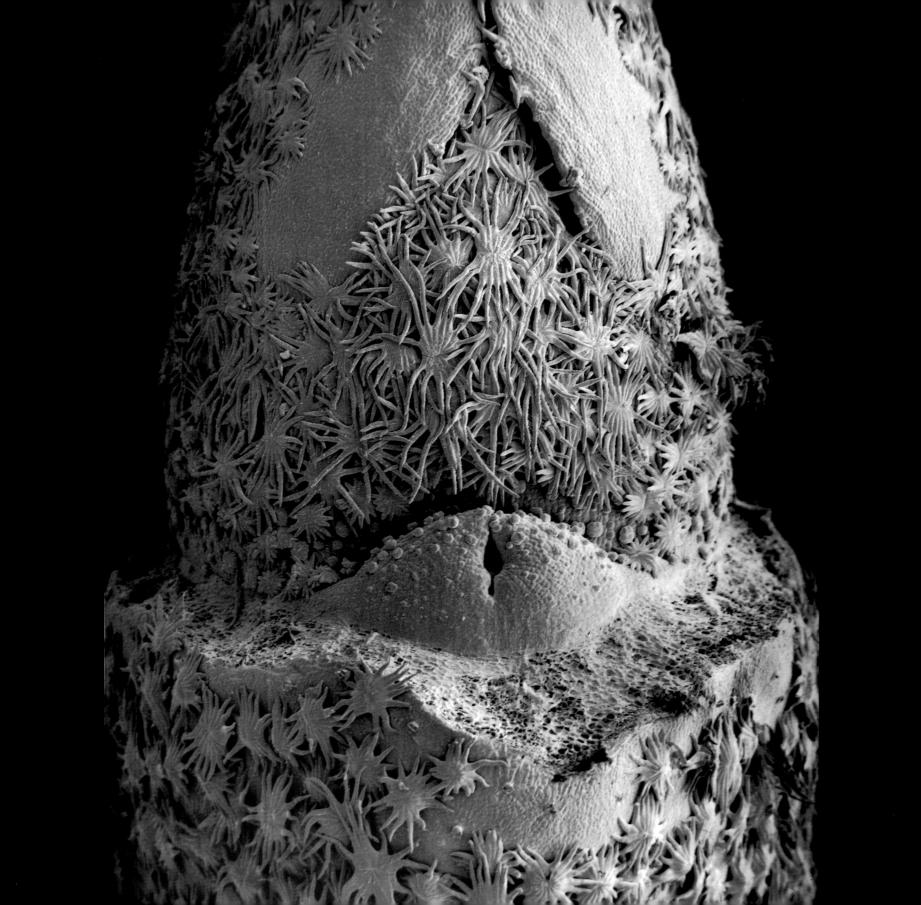

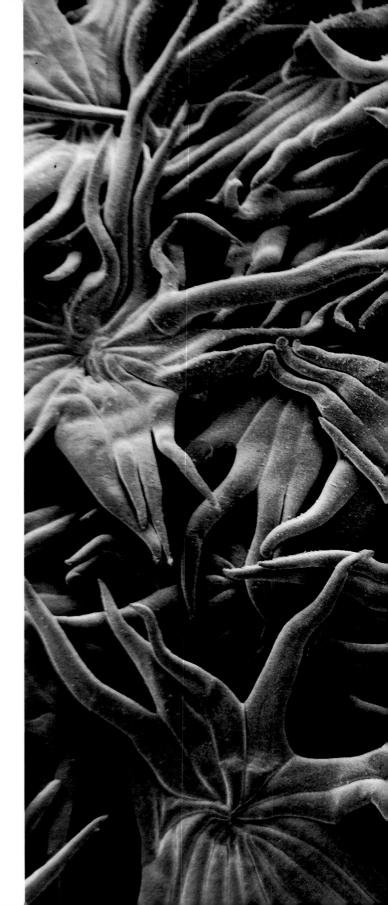

BURSTING FORTH FROM THE MICROSCOPE,
A SHOWER OF ELECTRONS CLEARED THE FOG
THAT KEPT MOTHER NATURE'S LEAST-KNOWN
MASTERPIECES FROM OUR EYES.

ABYSS

Protective hairs of ivy bud

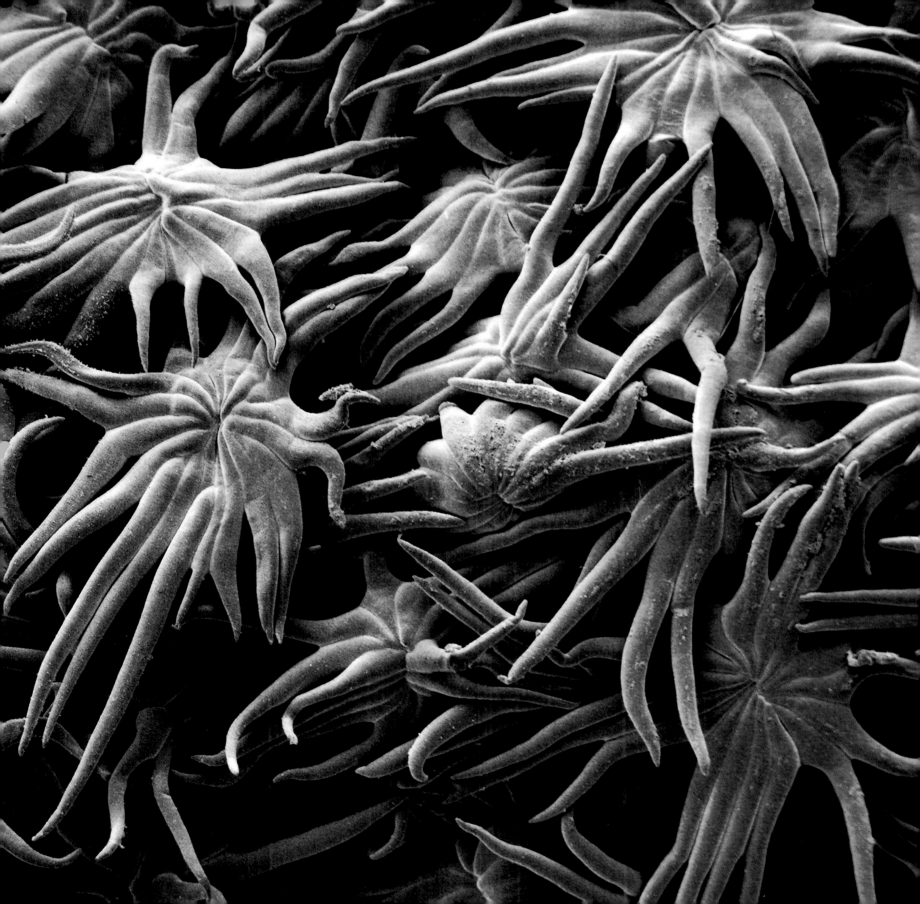

FROM WHERE COMES THE HARMONY THAT SEEPS INTO EVERY BIT OF LIFE?

PARADE

Detail of fly eye

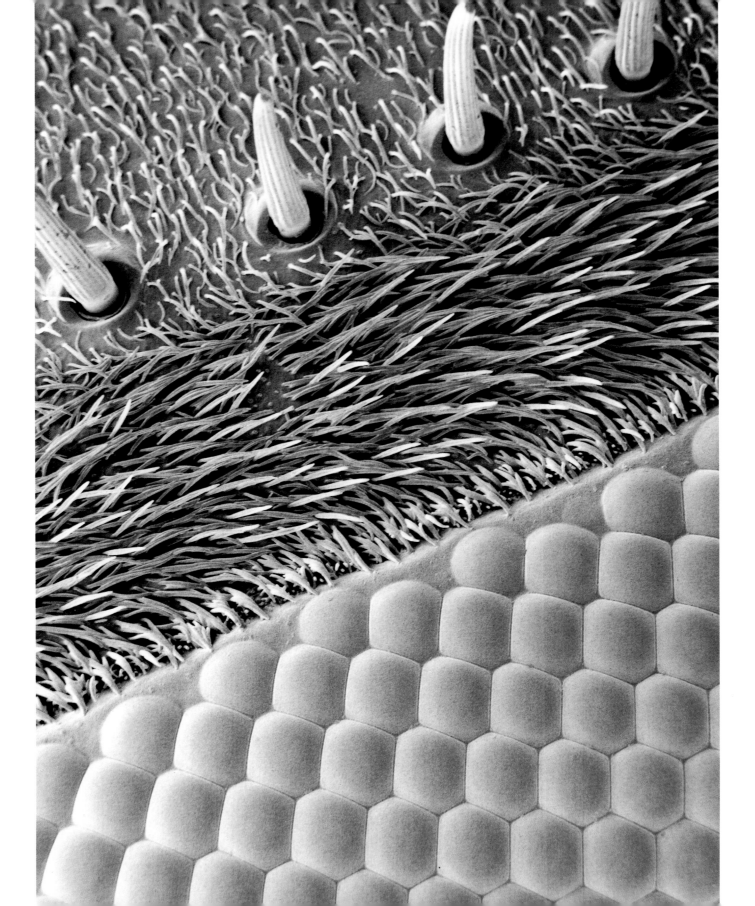

WHY IS THE SKIN OF THIS WOOD BUG AS BEAUTIFUL AS
LACE PAINTED BY VERMEER WHEN BY NATURE IT IS INVISIBLE?
JUST TO SEE IT, ONE MUST USE ARTIFICIAL LIGHT WAVES,
FAR INFERIOR TO THAT OF VISIBLE LIGHT.

LINGERIE

Skin of African bug

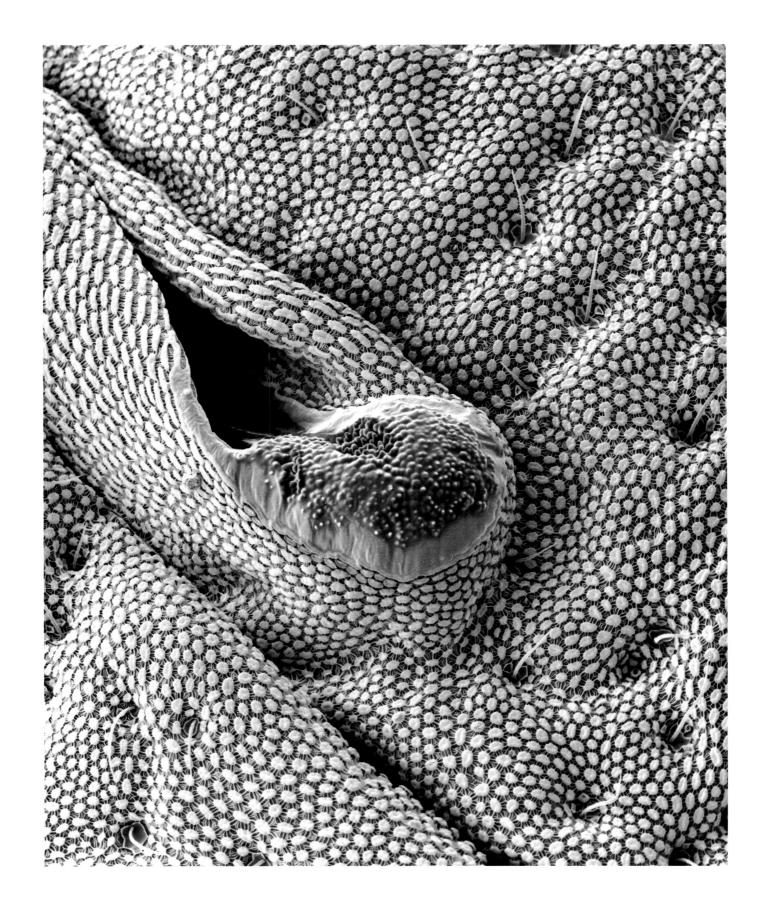

THE INVISIBLE IS PERHAPS THE DOMAIN OF "ABSOLUTE" BEAUTY...

ONE THAT NEED NOT BE OBSERVED.

LACE

Skin of wood bug (close-up)

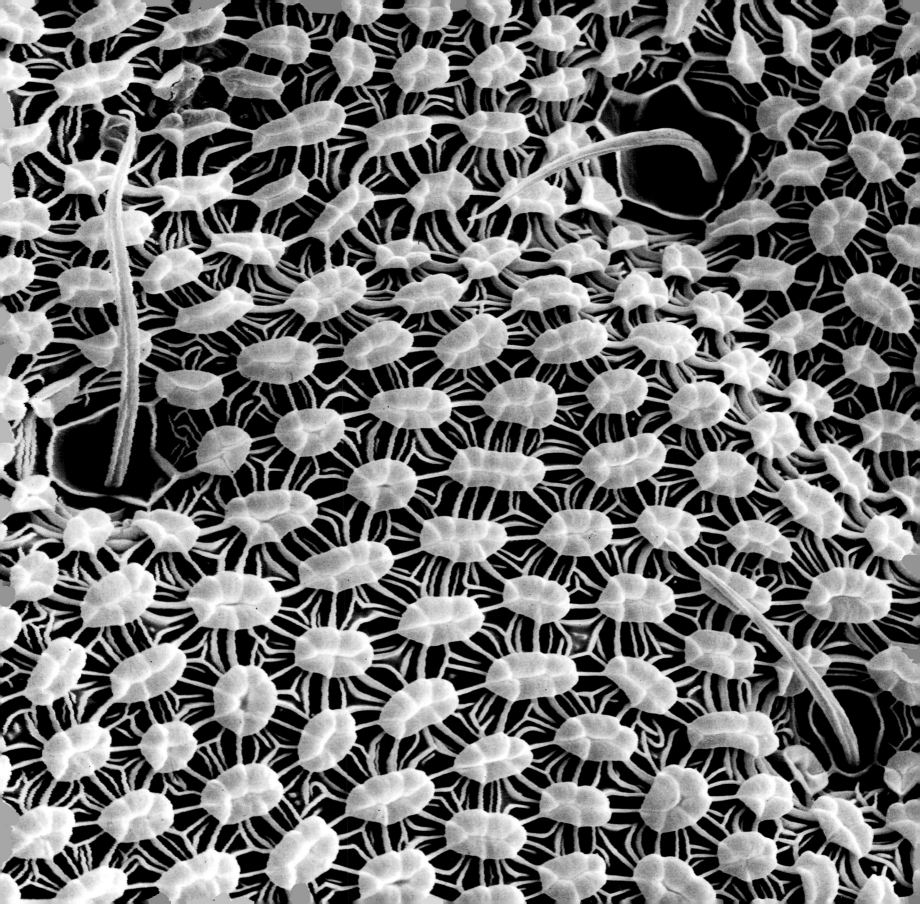

THE COSMIC SMILE

Respiratory pore of a gnat's abdomen

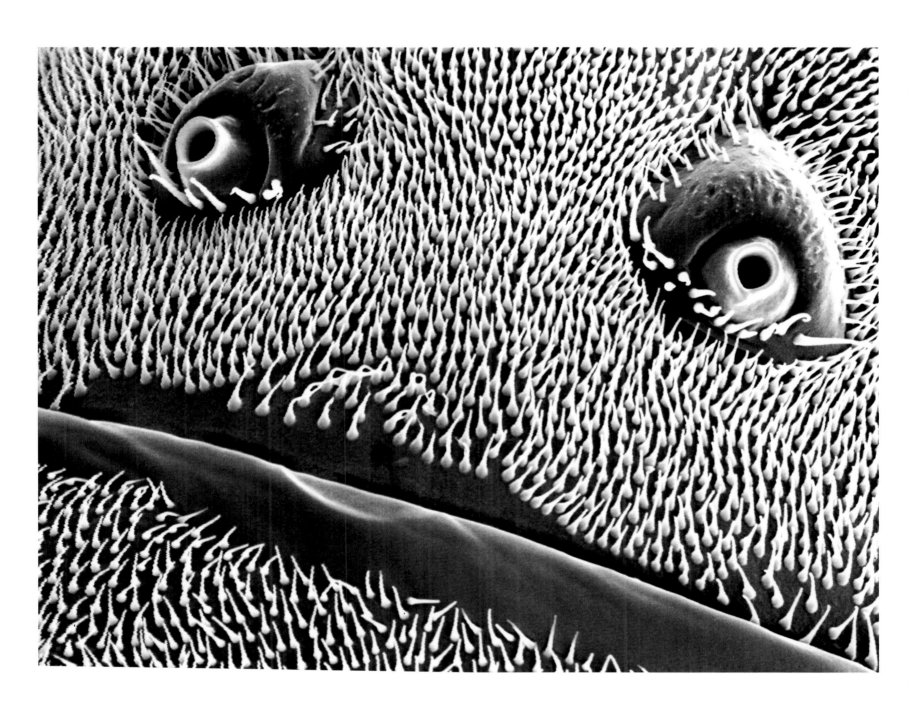

It is high time we bestow upon science more femininity, so that we finally recognize that, within nature, there is a form of cellular affinity and attraction.

Foreplay

Wild cowslip pollen

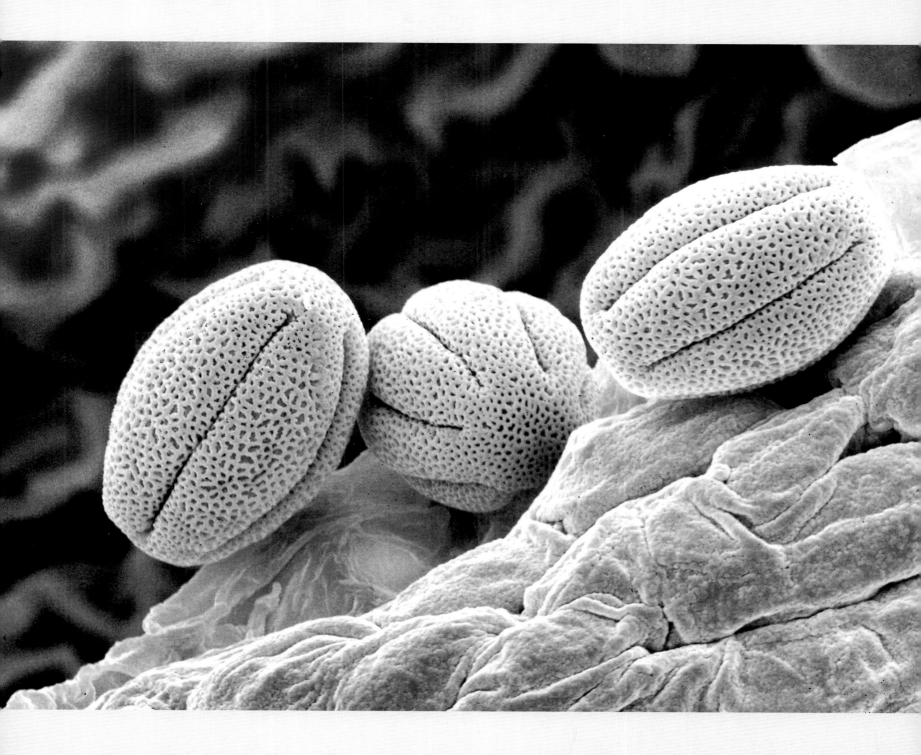

THE FIRST BACTERIUM THAT dared TO UNITE WITH ANOTHER
INSTEAD OF KILLING IT AND ABSORBING IT DID MORE FOR THE EVOLUTION
OF THE SPECIES THAN ALL MUTATIONS IN THE WORLD.
AND, DESPITE DARWIN'S VIEWS, LIFE, LIKE THE WOMAN WHO BEARS IT,
WILL ALWAYS PREFER MARRIAGE TO WAR.

THE ROOF OF A WORLD
Pollen on bee head

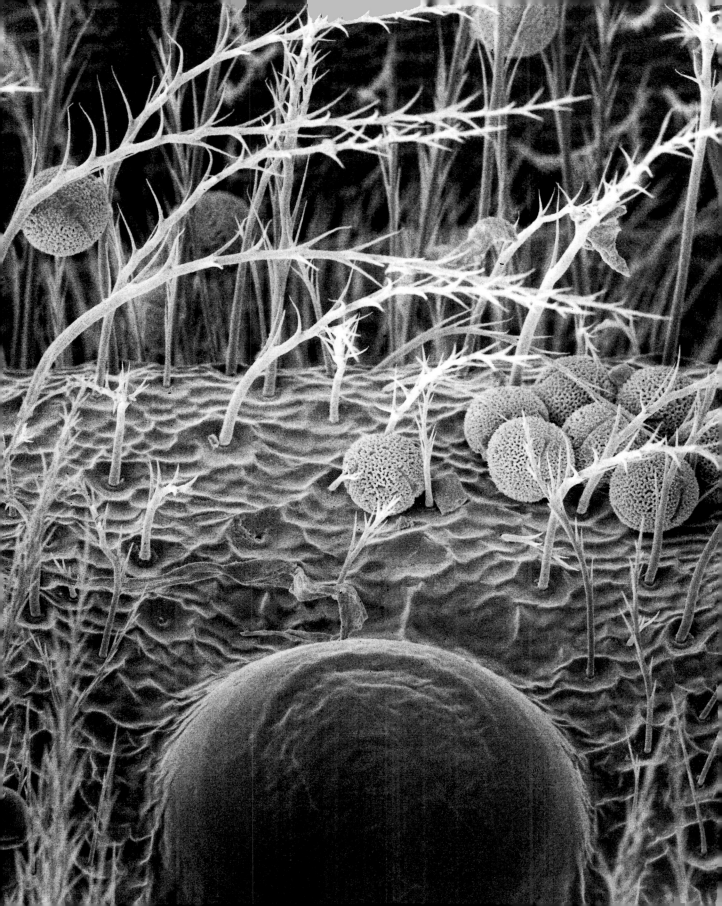

CHAPTER V

METAMORPHOSIS

Contemplative Biology

THE BEGINNING OF ALL SCIENCES IS THE ASTONISHMENT THAT THINGS ARE WHAT THEY ARE.
—ARISTOTLE

The astronomer cannot change what he sees through his telescope. And there is a good reason why! The celestial objects that he observes may have been dead for millions of years. But still, he remains filled with wonder. Similarly, in my laboratory of the minuscule, I observe without intervening and without manipulating. Some scientists are not satisfied deciphering the secrets of the living, but want to transform the world. I, on the other hand, have chosen simply to *contemplate* it. Like the astronomer, I observe. And like him, I am filled with wonder and ask myself what is hidden beyond the visible. I stand up against those researchers who manipulate life *without taking the time to contemplate it.*

For the moment, the gallery of invisible wonders is reserved for scientists. I hope this does not make them feel authorized to "correct" masterpieces, as if an entry ticket to the Louvre museum would give a visitor the right to change *Mona Lisa's* smile according to his will!

Molecular biology and genetics undoubtedly have the power to save human lives, but the pipette that draws living fragments from cells must above all be handled with respect and not filled with the ambitions of a demigod. In the Zen art of archery, masters teach their students to contemplate the target for a long time. Archers must first mentally unite themselves with the target and before shooting their arrow, thank it. To the researchers with armed pipettes, you must have also twinned your vision—one eye for knowledge, the other for *gratefulness.*

On the frontispiece of the Milan cathedral, the architect inscribed, "Ars sine sciencia nihil est." (Art without knowledge is nothing.) Are not scientists and artists twin brothers? Whether in the studio or the laboratory, using a brush or test tube, wearing a linen apron or a white lab coat, the artist and the scientist, whether or not a genius, pursue a common goal. Through different means, one seeks to define laws about the mysteries of the universe, the other to shed light on its beauty. They both propose new perspectives to expand our perception of the

world and walk side by side in the chaotic journey that is human culture. Pursuing their vocation requires technical competence, but above all, it is the boldness of their progress and the originality of their vision that can make them "masters" in their field. As the poet and biologist Jean Rostand said, "To clear the way for a new path, you have to be able to go astray." Down the roads of science, on the paths of art, just like on all trails that cross them, our vision is enriched when we first *metamorphose our perspective*.

Contemplative biology is both an art of discovery and a science of astonishment. It demands only one requirement—keeping one's eyes open. In conversational language, "I see" means "I understand"; what is dark becomes light, as if to be accessible to our intelligence, information had to be illuminated by our vision. Through gazing, my skill as a researcher softened, my observation became gentler, more respectful, and gradually, a quiet intimacy was established between my "models" and me.

Just like in figurative painting, I search for the light that springs from the material and I strive to render an image that is as faithful as possible. Addressing itself directly to our senses, the image crosses the language barrier and needs no translation. But magnification through a microscope produces a new perspective and leaves nothing that reminds us of the original subject. So facing a lunar landscape, I can avow, to paraphrase Magritte, "ceci est une fleur" (this is a flower), despite the fact that none of your senses will recognize it. My flower will have neither shape nor fragrance, neither softness nor even color. Unrecognizable, stripped of its concrete nature, it will seem abstract and imaginary to you, and yet your eyes will never have seen it so realistically. Slowly, you will feel it grab hold of your eyes and inundate your consciousness. Let it penetrate your inner universe and it will perhaps allow you, in Picasso's words, "to wash your soul of the dust of everyday life."

Transmutation

WHAT IS AT THE END IS LIKE WHAT IS AT THE BEGINNING.

WHAT IS AT THE BOTTOM IS LIKE WHAT IS AT THE TOP.

—HERMES TRISMEGISTUS

The equatorial forest is a universe where I wished I had Gagarin's spacesuit or Cousteau's diving suit. I returned from collecting my specimens covered in bites, pricks, and other inflations. But I was fascinated by that green world and came back euphoric. However, it is the expeditions into the invisible that have provided me with the most beautiful feelings. A free explorer, I do not have to answer to any "helmsman" demanding results. I do not crave gold or spices, my own El Dorado is the harmony of the world. And have I accumulated treasures. Like a gold digger sifts through gravel, I probe specimens that the layperson would ignore. Nothing makes me happier than to find beauty on the back of a scary spider or harmonious architecture where I expected monotonous terrain. I like to see my work transform the most insignificant fabrics into delicate

embroideries or cast a golden light on leaden-colored ephemeral cuirasses. The richness that lies in their depths is uncovered and fills me with wonder. I could spend hours gazing upon these Lilliputian splendors. Is beauty then a question of scale and perspective? Or is the electronic wave of the microscope a modern philosopher's stone capable of transmuting the insignificant into the sublime? The alchemists of the Middle Ages would have been enthralled by its power. It transforms not only the way we see but also the things themselves. However, in my eyes, the most stirring transmutation only appears after a certain degree of magnification. As if by magic, everything that is observed under the microscope, all living matter whether plant or animal, suddenly looks gray and telluric like a mineral. When touched by the electron waves, the butterfly, lizard, daisy, and coral all reveal an inorganic material

similar to anthracite. These cold blocks of granite rising up under my microscope are made of the very same substance as the tender poppy that I placed there. How can cells that look so stony be the source of such soft grace? I think about the words Baudelaire used to describe a statue he glimpsed in a garden:

"I am beautiful, O mortals, like a stone dream.
And my breast that has bruised one after the other
Is made to inspire the poet with love
Eternal and long-lasting, just like the stone."

From what dream, therefore, was this delicate poppy born? This budding flower that danced in the first wind of the dawn. What drop of infinity does it spill upon us from its granite calyx? Of course, this material does not amaze us as much as gold, but it is from the former that we too are built. Our eyes contemplate proof of life's unity and the brotherhood that binds living beings. As the astrophysicist Hubert Reeves reminds us, "made from protons, electrons and neutrons, we are all cosmic dust and it is the stars that gave birth to us."

The Flight of Harmony

Life, like the waters of the ocean, only softens when it rises toward the sky.
—Alfred de Musset

The metamorphosis of the chrysalis into a butterfly holds greater wonder than the most beautiful fairy tale. No poet could have dared to imagine a more accomplished destiny. Here is a myth told in the heart of the twig forest. Barely out of its egg, the little caterpillar has to crawl on the leaves and relentlessly gnaw on the green sustenance. To intimidate voracious birds, it disguises itself as a hairy dragon and is ready at any moment to cover its predators in a fiery liquid. Protected by a helmet of hair, its three primitive eyes are almost blind—they do not see the surrounding world and are sensitive only to the intensity of light and thus, are turned skyward. Suddenly, whether by the influence of the moonlight or the burning rays of the daystar, as if by a higher calling, the monstrous larva ceases to nourish itself. Does it now aspire to more noble needs or is it nursing some even more delicious ambition? As if taking refuge in its thoughts, it comes to a halt. Does it resent nature for making it crawl along when it feels it could conquer the air? It dreams (what audacity!) that it can fly like a bird! Did not the mythologies of the sprite people teach that birds themselves were born from dinosaurs who had dreamed of flying? Why then not the caterpillar as well? Nothing is more powerful than a beautiful, pure dream. And so, to spin around if only in graceful dreams of flight, it weaves itself a silk bedroom and then locks itself within its shelter. By will, the caterpillar soon grows wings inside this little cradle and through burning desire, its dream comes true. It is reborn a butterfly.

The power of a child's dream is strong enough to create animals in clouds, and I like to think that the butterfly that dances in the rays of the sun was born from the caterpillar's vivid dream. "We are such stuff as dreams are made on," wrote Shakespeare. The hairy and boorish animal became finer and more seductive than the most delicate of birds. Having been blind, with its new eyes it now gazes at the beauty of flowers beneath which it hovers, breathing in the fragrance, delighting in the nectar and dreaming only of marriage and drunken love. Alfred de Vigny could have dedicated a poem to it. "Friends, what is a great life if not a youthful thought performed by maturity."

The butterfly, even more than the flower or the blade of grass, symbolizes the rebirth of spring. As it comes out of its winter sleep, nature tears at its cocoon of snow and immediately soars toward the sky, with all the forms of life in its wake. Like a newborn seeking the breast, it looks for the sun in order to devour its rays. This is no coincidence, for is it not from on high that myths draw the secrets of genesis? Inscribed on the pediment of faraway stars, the story of the universe evokes the most magical of all metamorphoses—that of primitive chaos into harmony. For life to take flight, it would have been necessary for inert matter also to transform and lock itself up in little cell cocoons. The strength of life hidden in a humble seed is so powerful that in germination, it is capable of splitting the hardest of rocks. What dreams have come true out of nothing! Such immensity is hidden in the minuscule! Breaking down barriers, rising up toward the light, growing and multiplying, life has continually created, expanded, and forged order from the undefined, as if

harmony were its law and artistic license. Entropy, that merciless charter of the universe that prefers chaos, is its enemy. Does life use harmony like an ally to stop blind destruction? The harmony that we feel before a masterpiece, does it not also give us the feeling of changing the course of time? Music can launch us on a deeply serene journey during which we see ourselves, as in a daydream, taking part in the dance of the stars. Like the chrysalis, cradled in its soft cocoon, we then feel our body turn light. We "awaken" intoxicated with love and contemplation, ready for new flight. For Chateaubriand, "man does not need to travel to grow, he carries immensity with him." Yes, and this flight of the senses, even if it is but fleeting, marks us with a magical nostalgia that will shine deep in our eyes for a long time. As if the fairy of harmony, tickling us with its wings, had revived in our dulled vision an exhilarating dream of metamorphosis.

INSCRIBED ON THE PEDIMENT OF FARAWAY STARS, THE STORY
OF THE UNIVERSE EVOKES THE MOST MAGICAL OF ALL METAMORPHOSES—
THAT OF PRIMITIVE CHAOS INTO HARMONY.

LILLIPUTIAN REEF
Zeolite crystal formation

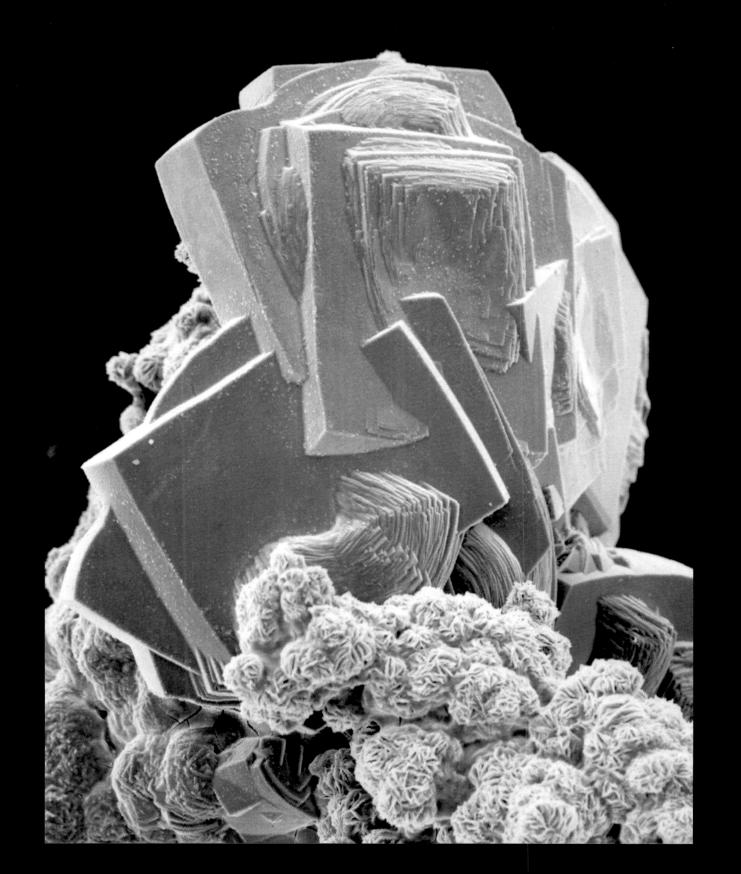

Or is the electronic wave of the microscope a modern philosopher's stone capable of transmuting the insignificant into the sublime?

Underwater Jewel
Fossilized microplankton

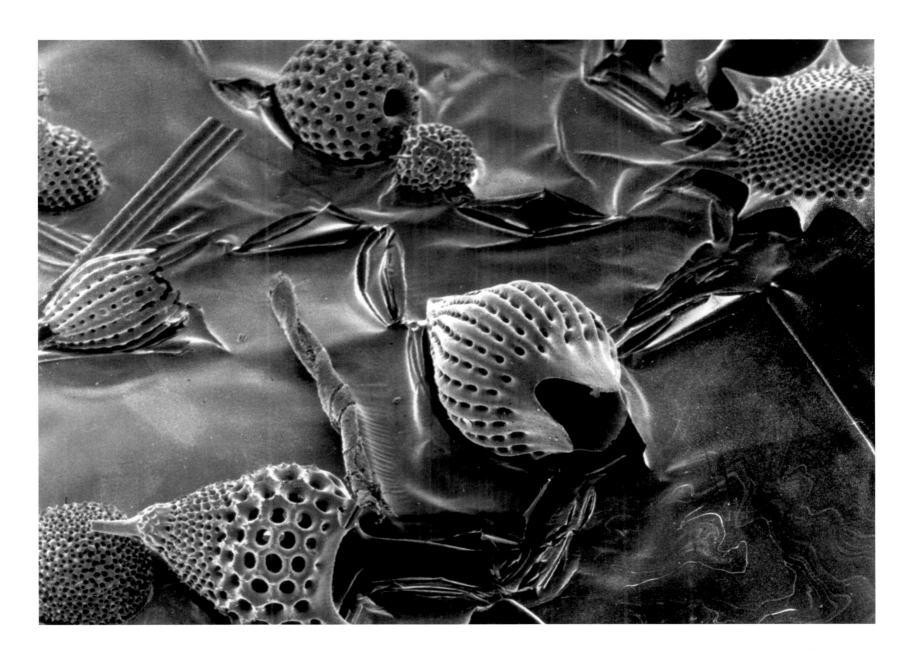

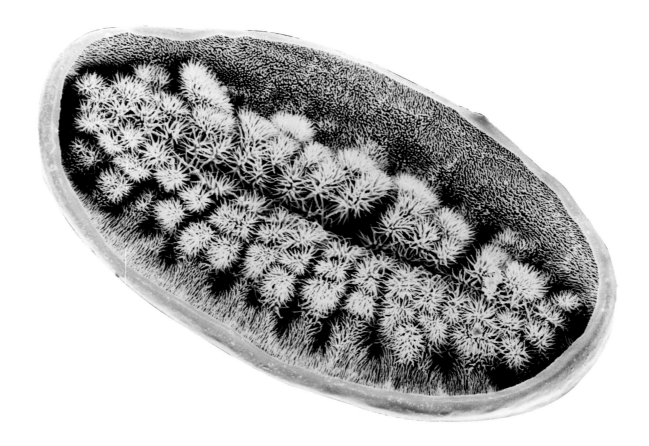

A T O L L

Respiratory pore of caterpillar abdomen

M E T A M O R P H O S I S

Butterfly skull

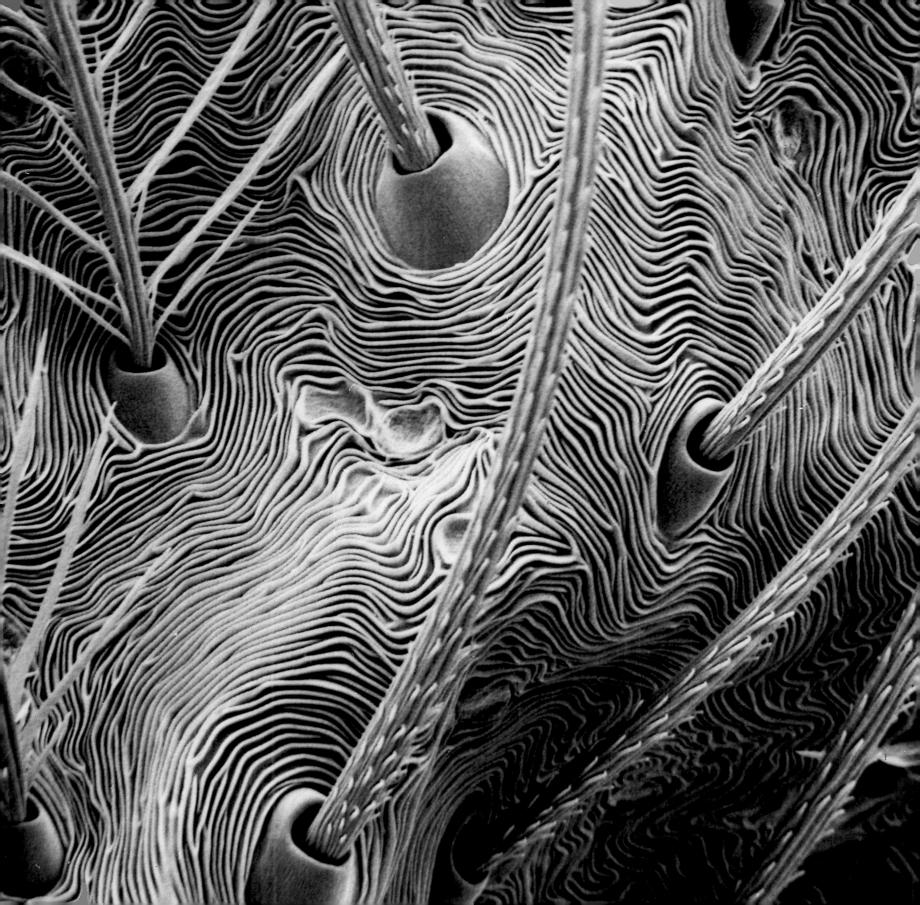

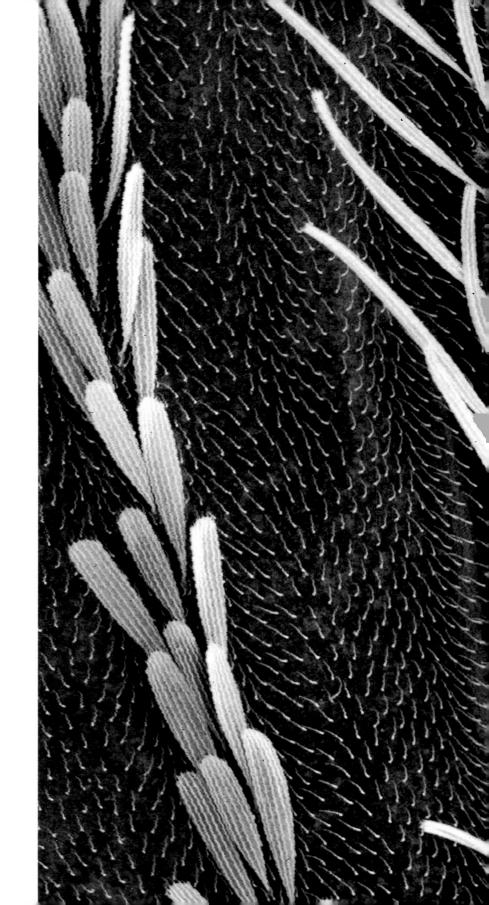

GARLANDS

Wing of Madagascar butterfly

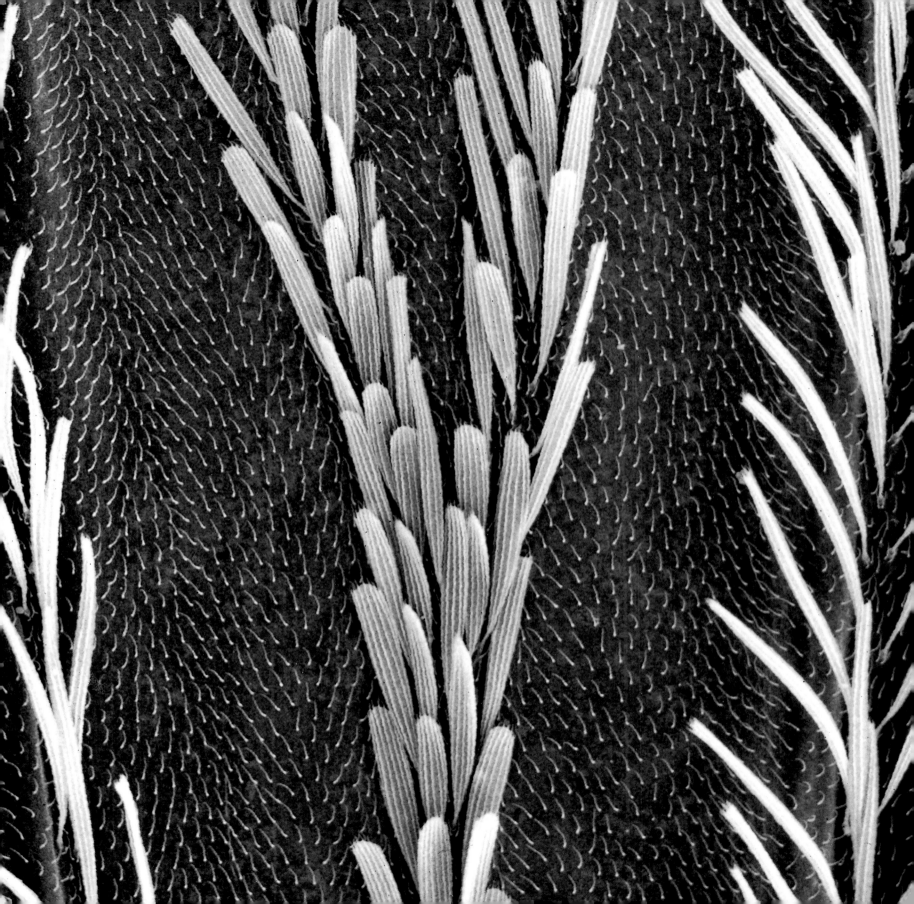

WHO SCULPTED THESE FLOWING ARABESQUES AND IN HONOR OF
WHOSE SPRING WEDDING ARE THESE GOSSAMER GARLANDS THAT
FLOAT ON BUTTERFLY WINGS?

FLYING CARPETS

Wing of Mexican monarch butterfly

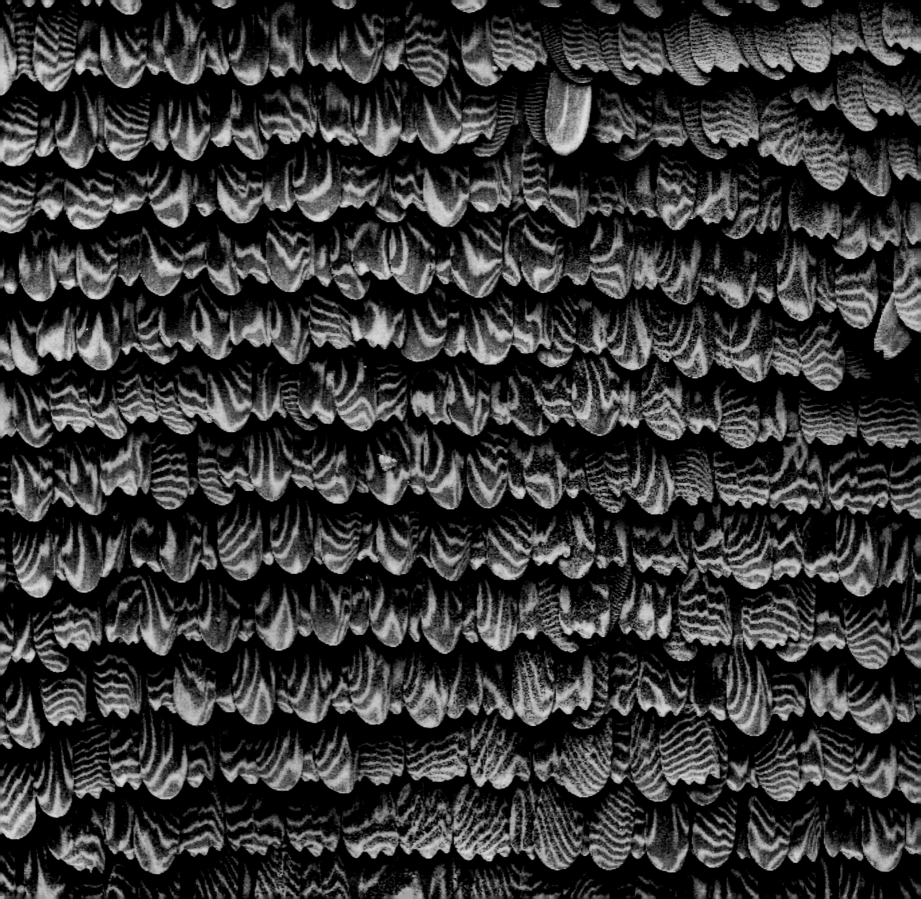

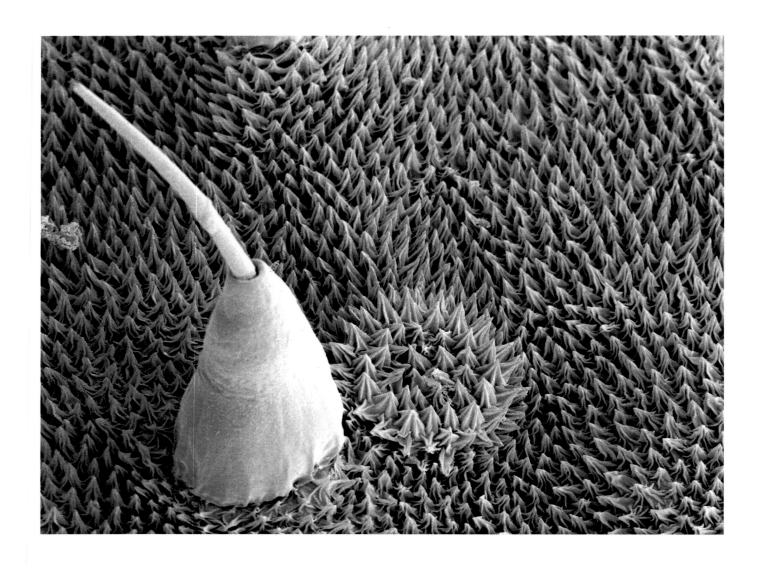

SILK FLOWER

Caterpillar hair

NATIVE LAND

Caterpillar skin

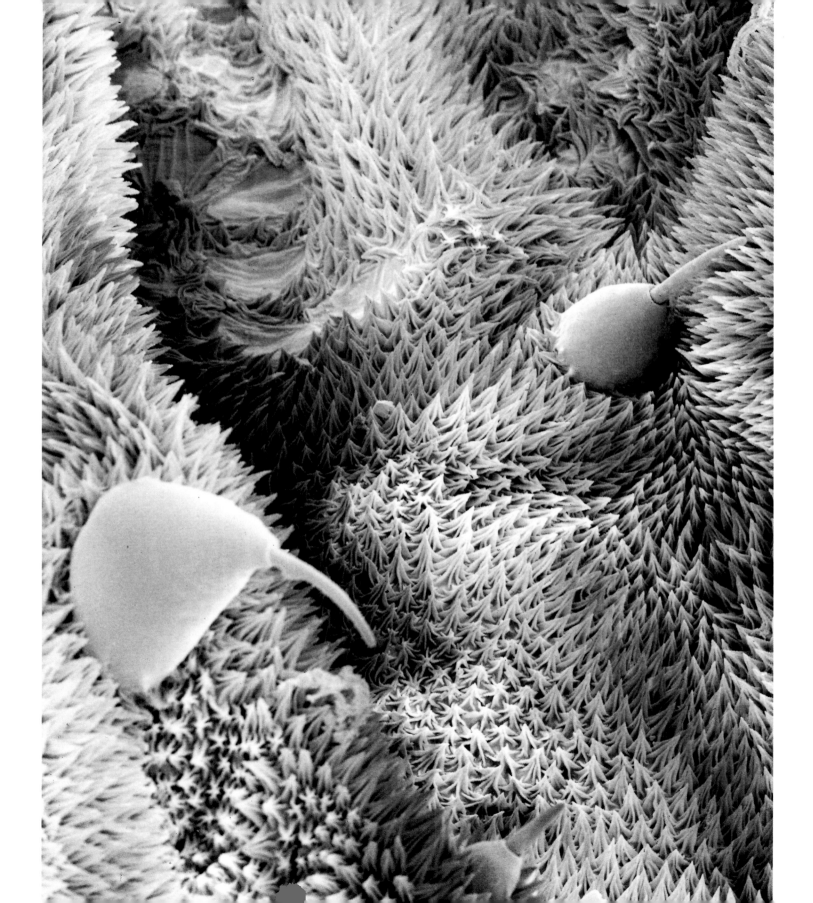

CONTEMPLATIVE BIOLOGY IS BOTH AN ART OF DISCOVERY AND A SCIENCE OF ASTONISHMENT. IT DEMANDS ONLY ONE REQUIREMENT—KEEPING ONE'S EYES OPEN.

IRIS

Respiratory pore of caterpillar abdomen

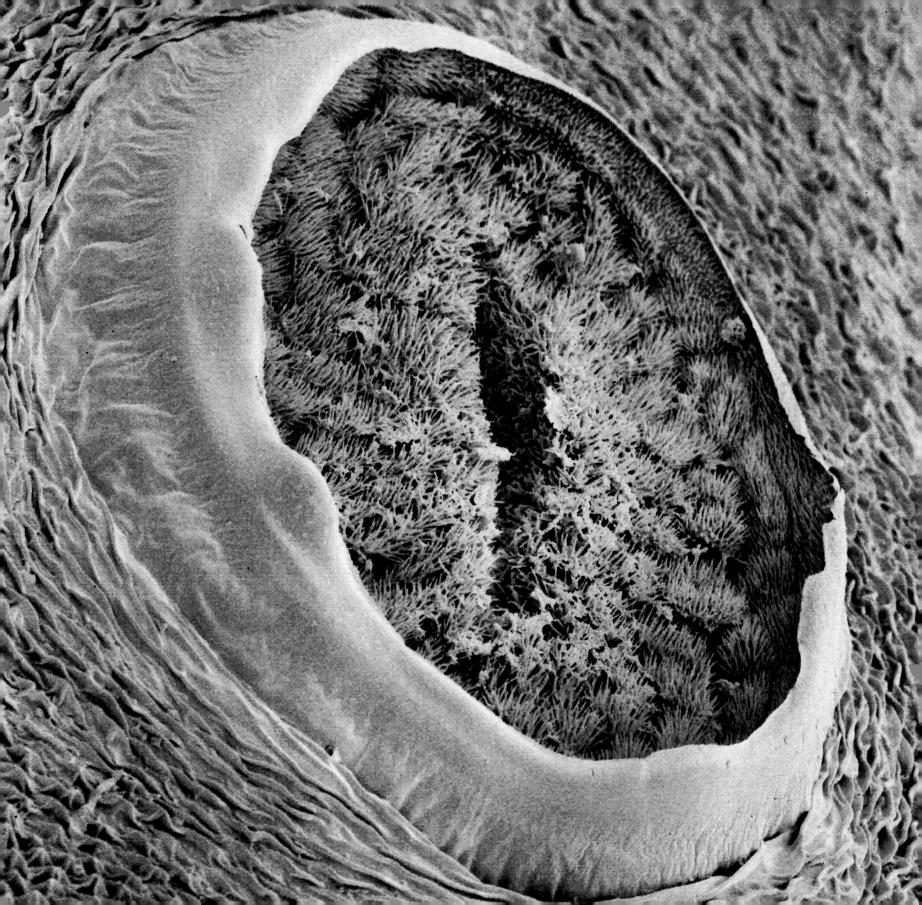

SUCH IMMENSITY IS HIDDEN IN THE MINUSCULE!

ANT'S ABACUS
Pollen grains

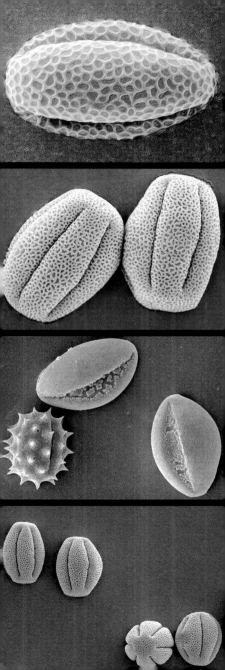

POLYPTYCH II

Various pollen

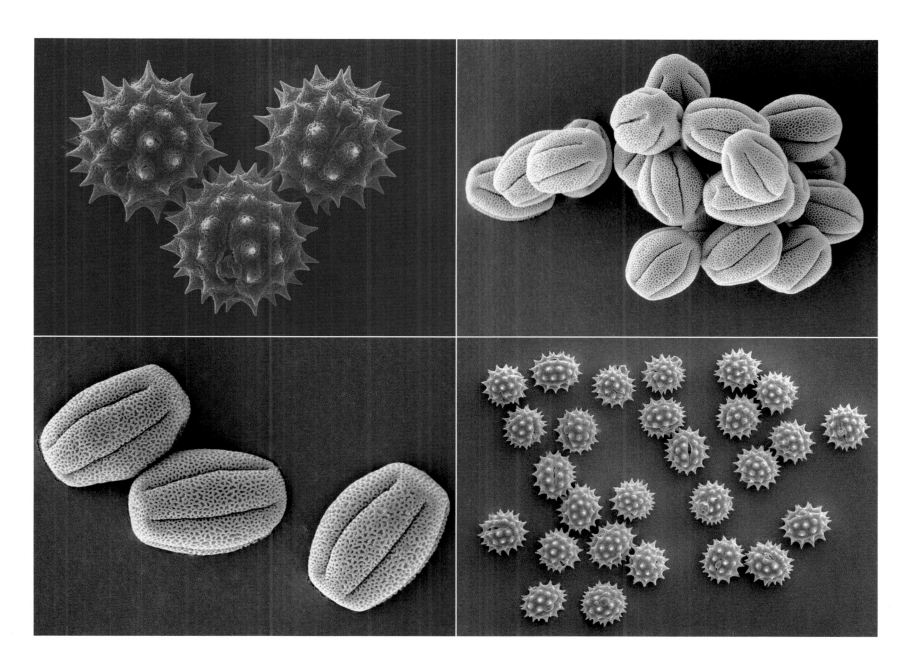

WHETHER IN THE STUDIO OR THE LABORATORY, USING A BRUSH
OR TEST TUBE, WEARING A LINEN APRON OR A WHITE LAB COAT,
THE ARTIST AND THE SCIENTIST, WHETHER OR NOT A GENIUS,
PURSUE A COMMON GOAL.

GOD'S GAME
Dust in a dragonfly's eye

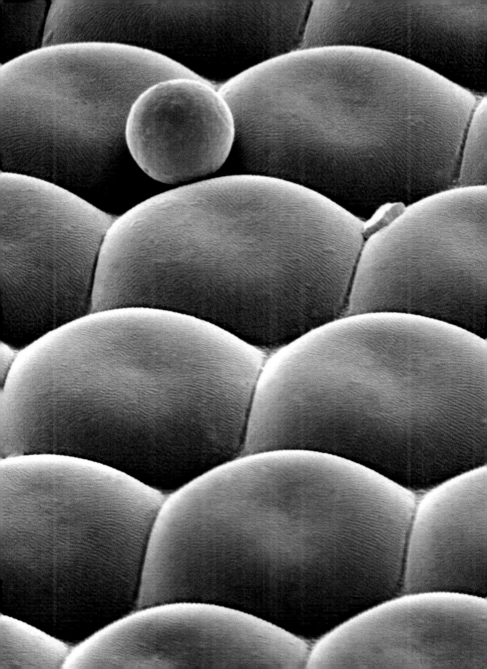

MADAME BUTTERFLY

Moth antenna

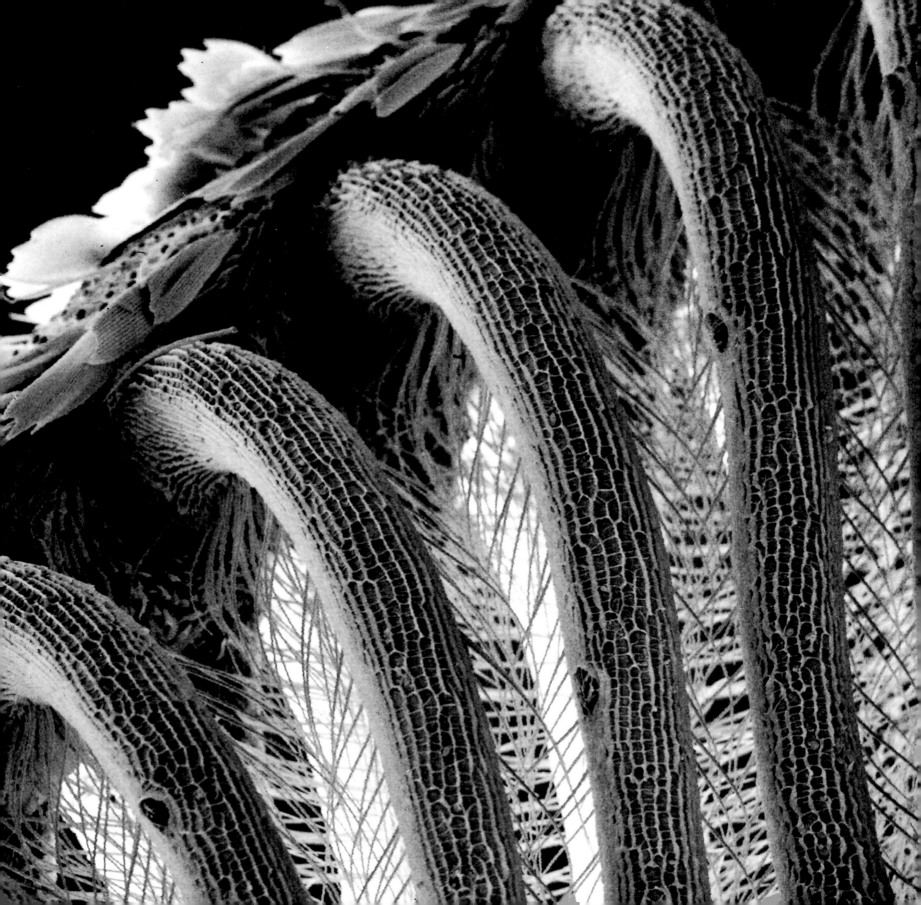

CHAPTER VI

THE RENAISSANCE OF VISION

LIGHT OR DARK?

THE QUEST FOR HIDDEN MEANING

NEW PERSPECTIVE ON THE UNIVERSE?

Light or Dark?

| 164

WHAT IS VISIBLE IS BUT THE REFLECTION OF WHAT IS INVISIBLE.

—RABBI ABBA

What do we really see when we gaze upon, for example, the image of a lost valley on the back of a beetle?

When the beam of the electron microscope is projected onto the bronze shell, the great majority of the stream of electrons is absorbed or crosses the insect right through. But, in passing, a certain number of particles belonging to the very matter of the beetle are dislodged by the jet of energy. A detection device then records their intensity. It is this process that allows us "to see" the relief. What reveals the contrasts of visible light on the photograph is in fact a topographical map, with rises and falls, faults and scarps. The observed image is merely a projection of reality, fabricated by the machine, and interpreted by our eye as a three-dimensional landscape. Should we therefore feel deceived by our perception? No, for the manner in which we see the world that surrounds us is not so different. What we really capture when we look, for example, at a tree is the echo of the particles of solar light (photons) that rebound off the bark and then hit our eyes. "The eye listens," as Cocteau wrote. Our brain reacts to these light waves and in return, presents us with a coherent image that it re-creates. Undoubtedly, it somewhat deforms reality. "A flaw in the window and the sparrow becomes an eagle on the roof," quipped Jules Renard. Perhaps what we think we see is only a pale reflection of reality after all. Plato interpreted our visions as shadows reflected on the walls of a cave. Had he lived in contemporary times, what might he have thought of these fantastic apparitions whose gleams of light cover the walls of the microscope like a modern cave with millions of electrons? In exploring the pits buried in the hills of

an ant's abdomen, you cannot help but muse upon prehistoric caves. For thousands of years, Lascaux, Altamira, and so many other caves yet to be discovered have hidden works of art engraved on their walls from which emanate a primitive aesthetic that is both anonymous and filled with supernatural beauty. Equipped with an extraordinarily sophisticated light, I find myself wandering through the bends of cellular corridors with the same astonishment as the prehistorian seeing mammoths come to life under his torch. What are these geometric forms, these sketches from another age? What are we to learn from these mysterious drawings? If "nature does nothing without a goal" and "keeps its final intention hidden from us" as Aristotle taught, then to which secret life plans do these drawings correspond? Nature clearly exhibits originality and a fertile imagination that is continually being renewed. It swarms with enigmas for which none of the theories of evolution has yet offered a satisfactory interpretation. We dissect nature to examine its microscopic and even chromosomal makeup. Removing the shell of a seed can help us understand the process of germination but does not explain the cause. A mysterious life force encourages the seed to grow. What is this creative impulse that pushes nature to such abundant forms, and to what end? When will humanity finally find out? What generation will have this privilege?

The Quest for Hidden Meaning

IT IS A SAD THING TO THINK THAT NATURE TALKS
AND THAT THE HUMAN RACE DOES NOT LISTEN.
—VICTOR HUGO

Our planet, like all living beings (but in a broader time frame), is driven by perpetual motion. Its landscapes are constantly transforming. Continents drift, water erodes mountains and hollows valleys, the wind ripples the sand. And now, as we scale the dunes of a colza petal, an imperceptible breath undulates the cells and they look like vistas seen only in the desert. But from where does this turbulence come, this agitation that causes a "volcanic" pore to erupt on the back of a spider? And the telluric jolts that give a silicon crystal a Himalayan relief? Looking at a fern under a microscope, you will find the same leaf cutouts which when life-size would attract the attention of someone strolling through the forest. A pigeon feather, enlarged several thousand times, divides into barbs and barbules, all with the same initial mesh. Some forms seem to repeat like this infinitely. Physicists call this selfsameness a fractal, but we know neither its meaning nor purpose. Nature, as if it had its preferences, gives us the impression of preferring the emergence of beauty.

For the zoologist D'Arcy Thompson, the answer would be linked to the laws of physics. Before Réaumur invented his thermometer or Newton discovered light waves, heat and color were also considered to be subjective qualities, dependent on the observer's judgment. As soon as these two scientists calculated them with an instrument, our perception of the world was drastically altered. Today, beauty, like heat and color in the past, is not seen as an "objective" value. Perhaps one day, some scientist will discover that its physical value can also be measured. Will a physicist of such genius and audacity ever exist who will be able to explain beauty as if it were merely the result of a play of forces and quantifiable interactions?

In contemplating the friezes and sculpted bas-reliefs in the invisible, I have the same spiritual feeling that the peasant from the Middle Ages must have had setting his eyes upon a cathedral. How could one not believe in the divine in the face of such beauty rising up as if by magic? A painted Madonna or a delicate rosebud command the same respect from me, both inspire as much self-reflection and make me question the meaning of such a profusion of beauty.

A short story by the Argentine writer Jorge Luis Borges entitled "The Writing of God" offers a poetic hypothesis. We meet an Aztec priest, a prisoner of the conquistadors, who is left to rot in the depths of a dark cell. In the next dungeon, a jaguar suffers the same fate. The Indian can only see it a few minutes a day when the trap door is opened and the two captives are fed. He is convinced that his god has left his mark on all his creations, in particular, on the coat of his fetish animal, the cat. If the priest could read the divine secret on it, the discovery would bring him the power to free himself. For years, he observes and memorizes the labyrinth of markings on the fur. When finally he is able to understand the code, he acquires absolute power, but in the same instant, he renounces using it. Having under-

stood God's design, his own imprisonment loses all importance. This is a story that deeply touched me because, in all the hours I have spent gazing, I have also had the feeling that I am brushing up against something infinite, sacred. Without being able to grasp the meaning, of course, I infer a secret beyond our reach. This mysterious beauty is like a magnet, I attach myself to it and nothing can take me away from my contemplative joy! As if the tissue of my retina were merging with the fabric of the flower I am looking at, the sensation of some cosmic fragrance invades my entire being. My photographs are born from this "petal soft" vision. They cannot answer to my questioning, but become offerings and are my way of expressing my gratitude. They are meant to be a humble homage to the beauty of the world.

New Perspective on the Universe?

Forms haunt us and monopolize our vision. Unconsciously or for pleasure, we are always trying to compose images that are familiar to our mind. We create them in inkblots and in clouds. It is as if chaos bothered us. Perhaps in our thirst to understand and dominate our environment we have become predators of information. Because the formless is not easy to digest, we seek to satisfy our neurons by offering them simple forms. Instead of comforting ourselves with identifiable shapes, we must force ourselves to improve our perception of the unknown. Many other wonders, still indiscernible, could enrich our universe.

Neural network robots, in which Massachusetts Institute of Technology researchers are trying to instill a vision of their environment, are able to discern certain obvious shapes. Their "consciousness" therefore amounts to recognizing those objects within their environment. Those that they cannot identify simply do not exist. Their vision seems so limited to us that we feel compassion for their big steel eyes. Yet, is not the invisible also our everyday life? Our eye is incapable of perceiving the ultraviolet nuances by which flowers attract bees and we are filled with admiration for a bird's ability to see. An eagle perched on the highest branch of a sequoia tree can spot a salmon swimming in dark water a few hundred yards away. In Africa, the Bushman identifies animals and determines their sex and age well before the uninitiated can see their silhouettes, even through binoculars. Eskimos easily orient themselves on a flat ice floe, whereas for us, it is an unchanging expanse of white that disappears into the horizon.

"Being," wrote the philosopher George Berkeley, "is to be perceived or to perceive." Vision is a privilege that we all must strive to conquer. Discerning the invisible bestows the keys to knowledge and contemplation.

However, just like the horizon, the invisible is boundless. It cannot be grasped, possessed, or controlled. When we believe we have defined the invisible, it becomes even vaster and slips through our fingers as we hunt it down. Its beauty arouses our lust and awakens our desire to see. A hunter of horizons is nestled deep inside us and dreams of winning over the limits of the unknown. It is human nature to court mystery, to want to attain the inaccessible, to seek to understand the inexplicable. When we wander blindly to the frontiers of science, it is to pursue further our insatiable quest. It is in the invisible that beauty shines…but we are not aware of it because we are mere novices of perception! Harmony radiates before us without our knowing it. Let us learn to contemplate it and before our eyes, the doors to new and boundless universes will finally open. As Cyrano de Bergerac murmured, is it not true that "it is at night that it is wonderful to believe in light?"

AN IMPERCEPTIBLE BREATH UNDULATED THE CELLS AND
MADE THEM LOOK LIKE LANDSCAPES ONLY SEEN IN THE DESERT.

COLZA DESERT

Colza flower petal

I FIND MYSELF WANDERING THROUGH THE BENDS OF CELLULAR CORRIDORS WITH THE SAME ASTONISHMENT AS THE ARCHAEOLOGIST SEEING MAMMOTHS COME TO LIFE UNDER HIS TORCH.

MAMMOTH

Sensitive hairs on a wasp's head

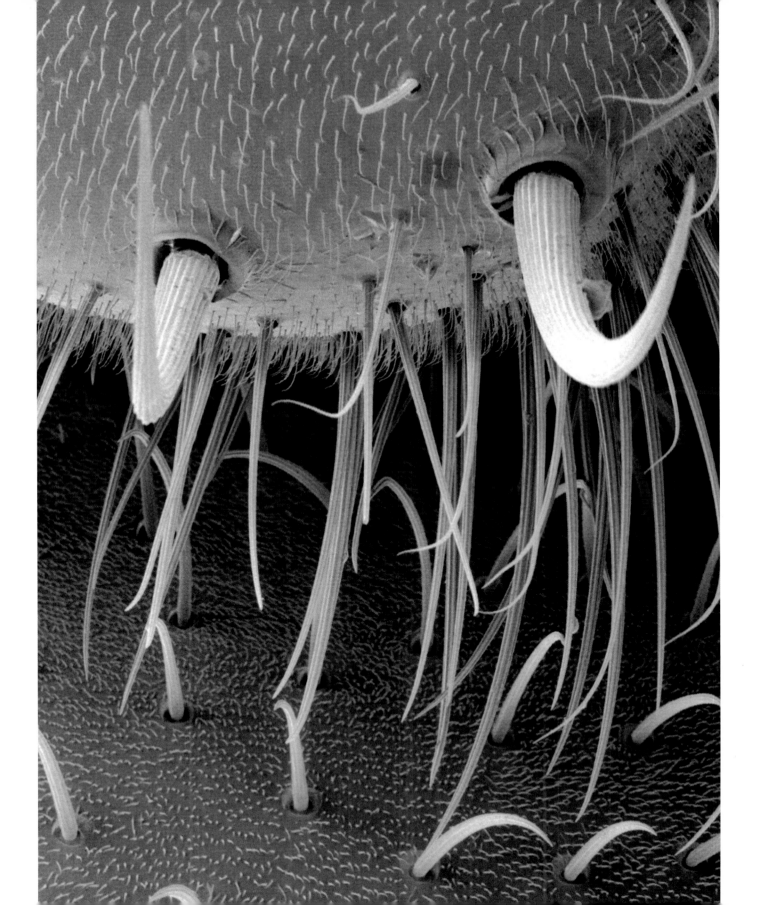

TROPHY

Beetle claws

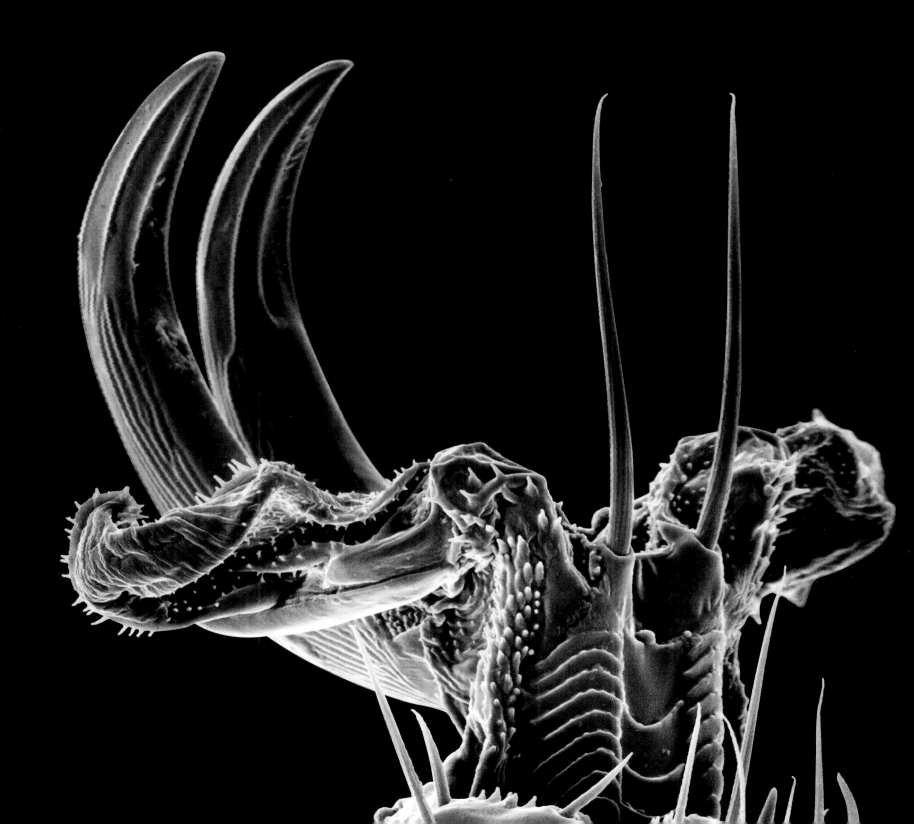

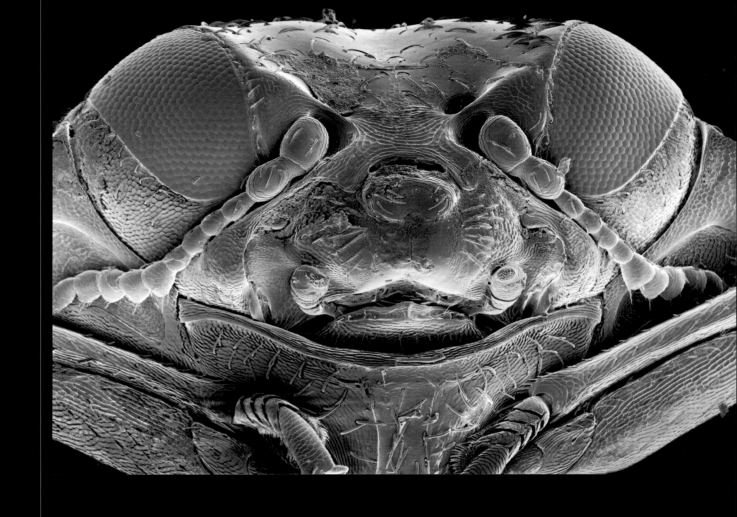

DOGGY-BUG

Portrait of coleopteroid

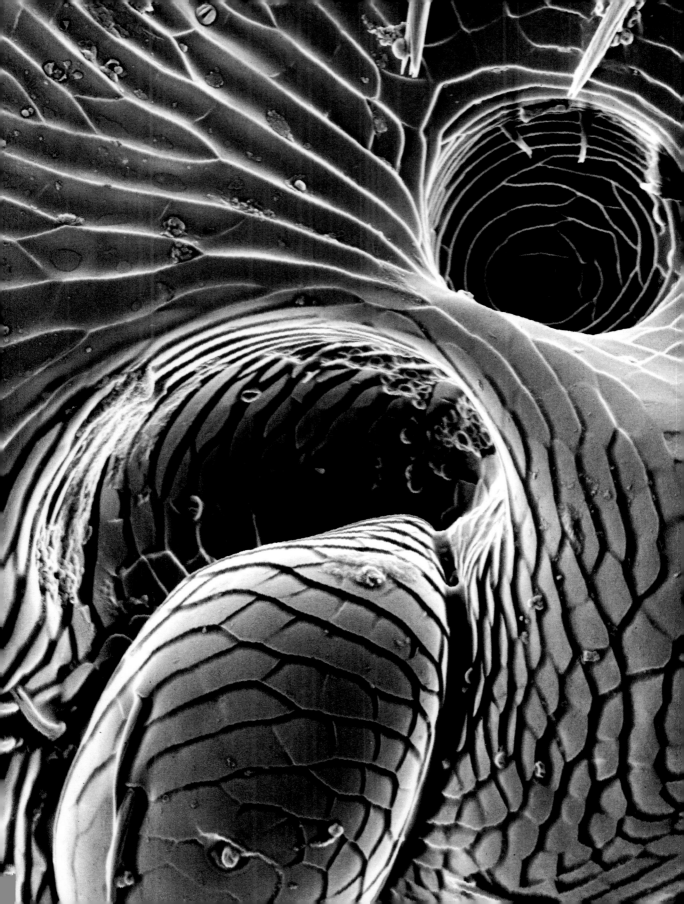

BEFORE ALL, THERE WAS THE ABYSS,

OR STILL THE EMPTINESS

AND LOVE, THE MOST BEAUTIFUL AMONG

THE IMMORTAL GODS...

—HESIOD

INVISIBLE ORGANS

Landscape on metal

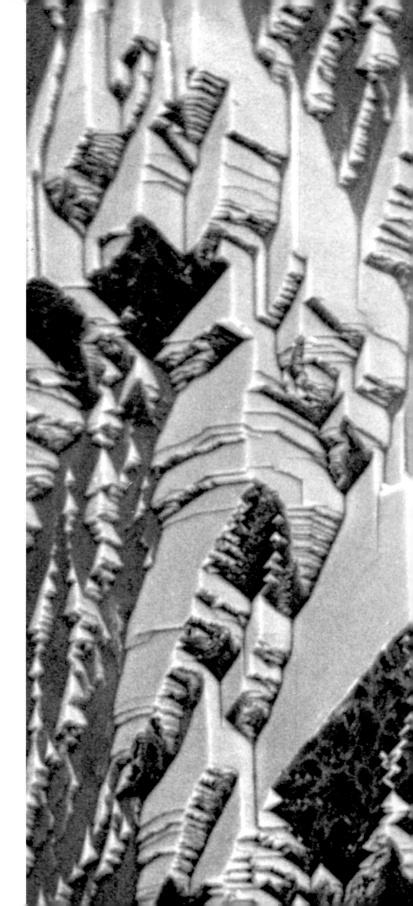

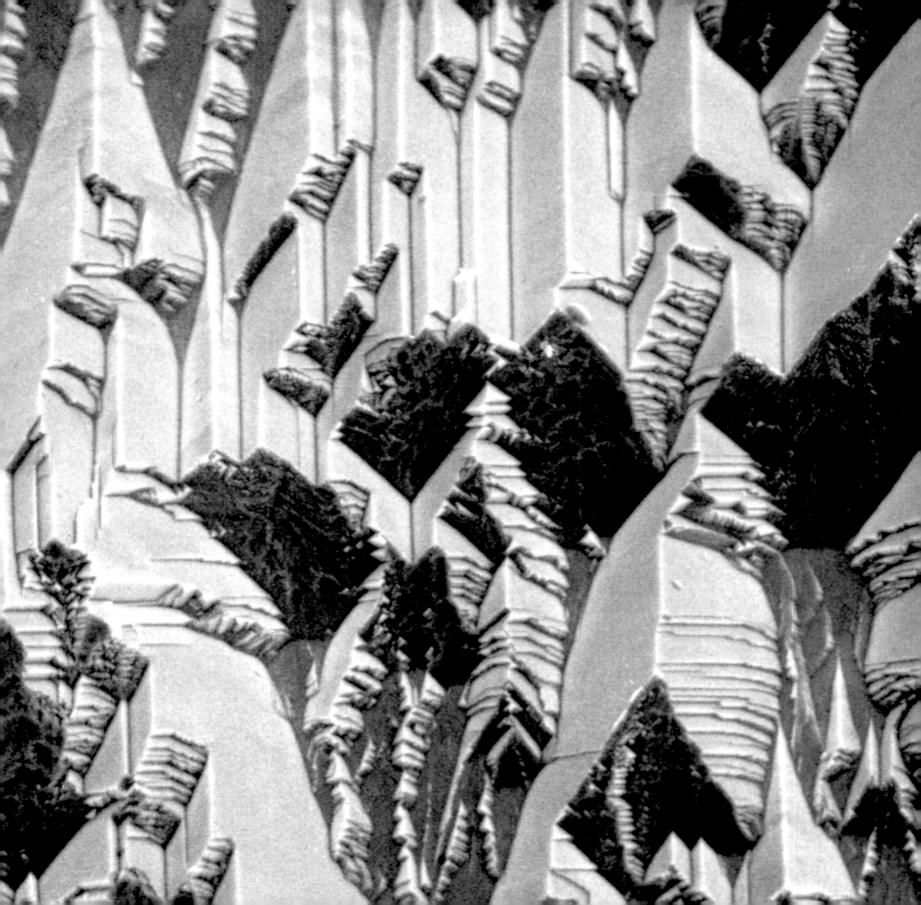

Every flower is a soul of budding Nature.

—Gérard de Nerval

FLOWER SECRETS

Floral buds and yeast (composition)

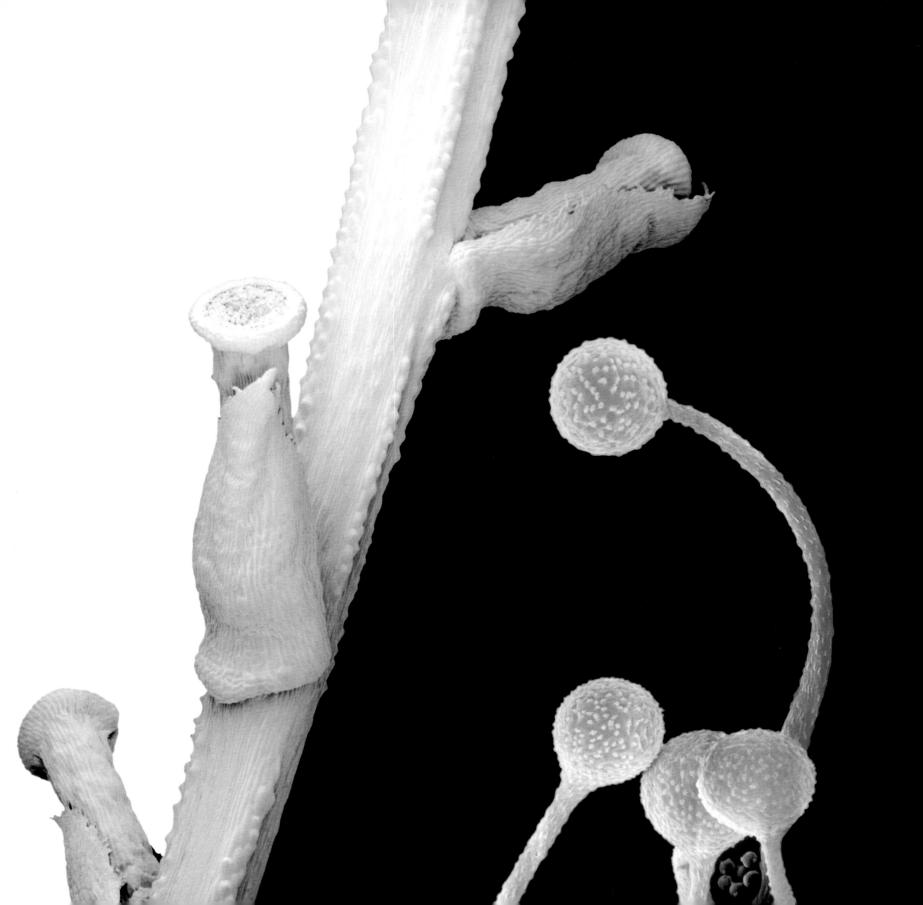

WHAT IS THIS CREATIVE IMPULSE THAT PUSHES NATURE
TO SUCH ABUNDANT FORMS AND TO WHAT END?

PERFUME

Secretory hairs of olive-tree flower

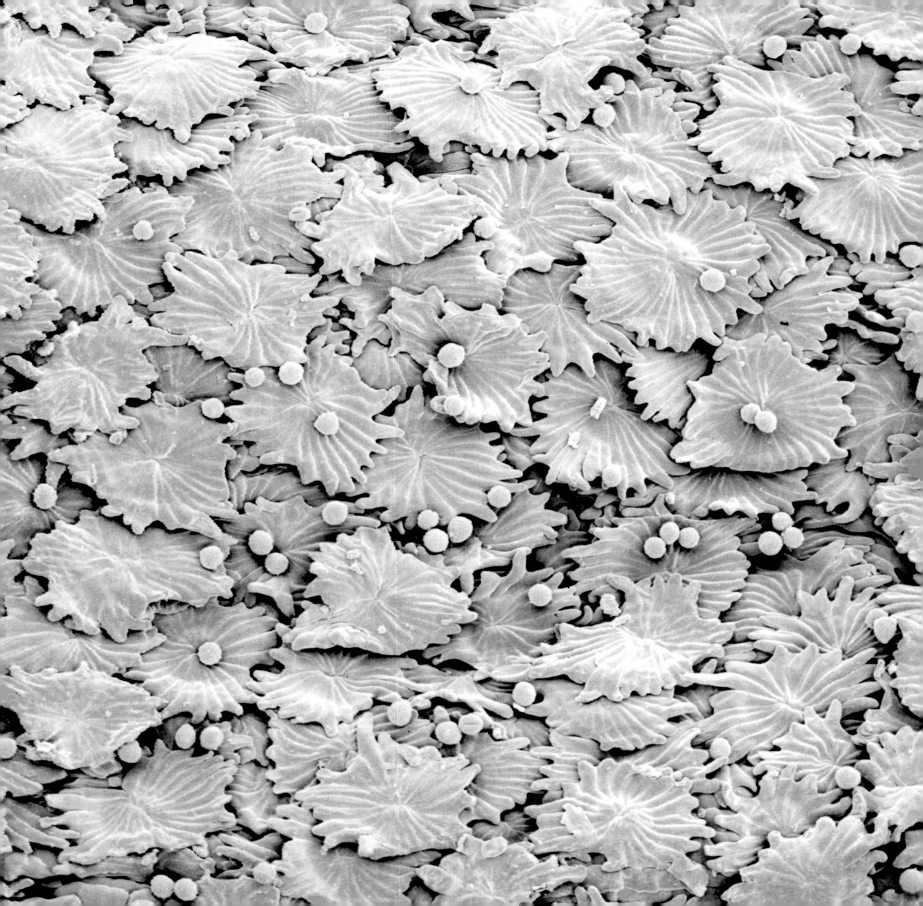

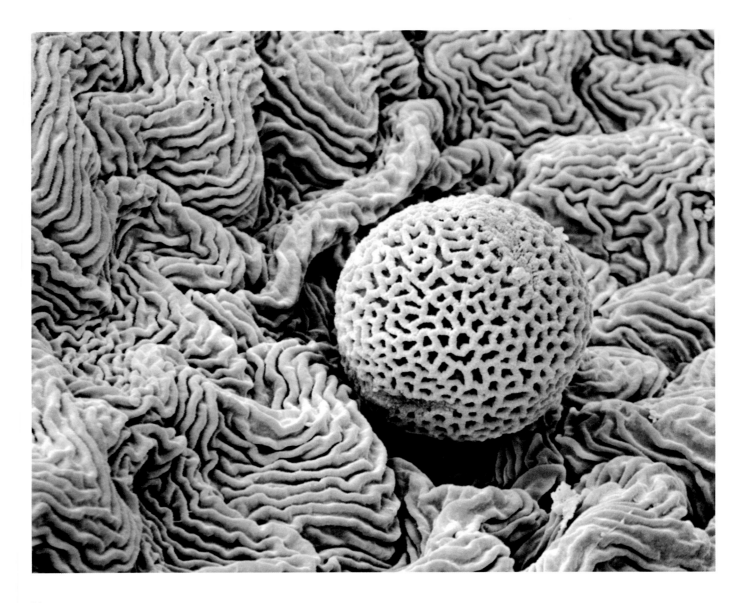

NATURE GIVES US THE IMPRESSION OF PROMOTING THE EMERGENCE OF THE BEAUTIFUL.

BALANCE

Olive-tree (or poppy?) pollen

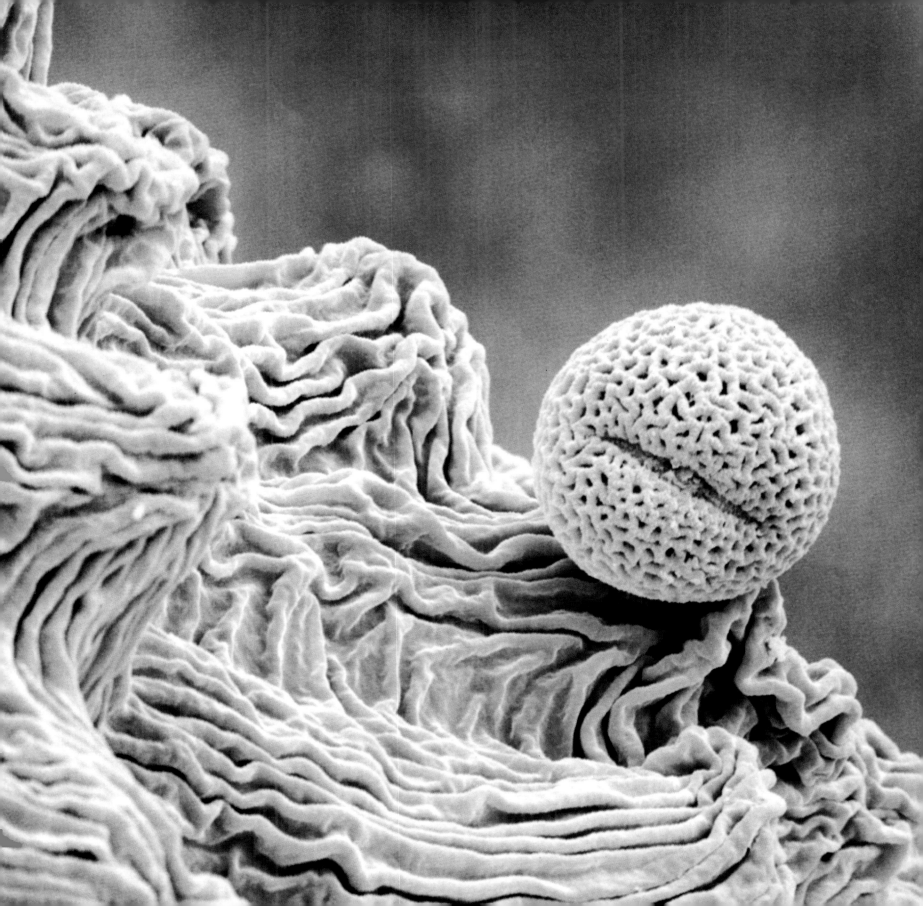

THE ONLY DOMAIN IN WHICH THE DIVINE IS VISIBLE IS ART, NO MATTER WHAT NAME WE GIVE IT.

—ANDRÉ MALRAUX

MATISSE'S BOUQUET

Plant dust through a microscope

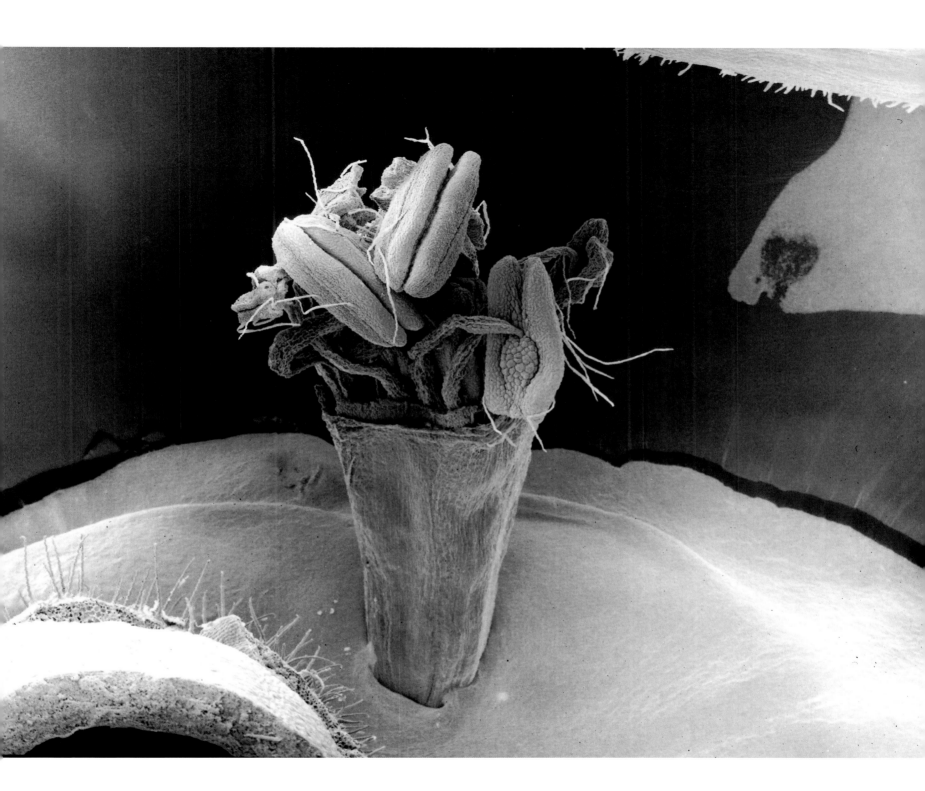

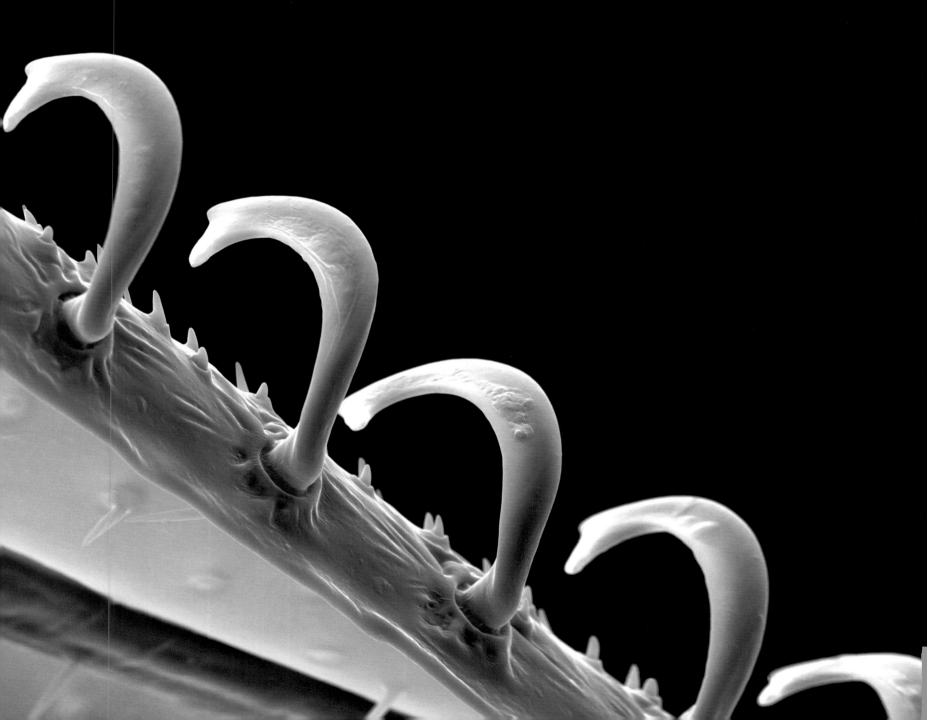

DISCERNING THE INVISIBLE BESTOWS THE KEYS OF KNOWLEDGE AND CONTEMPLATION.

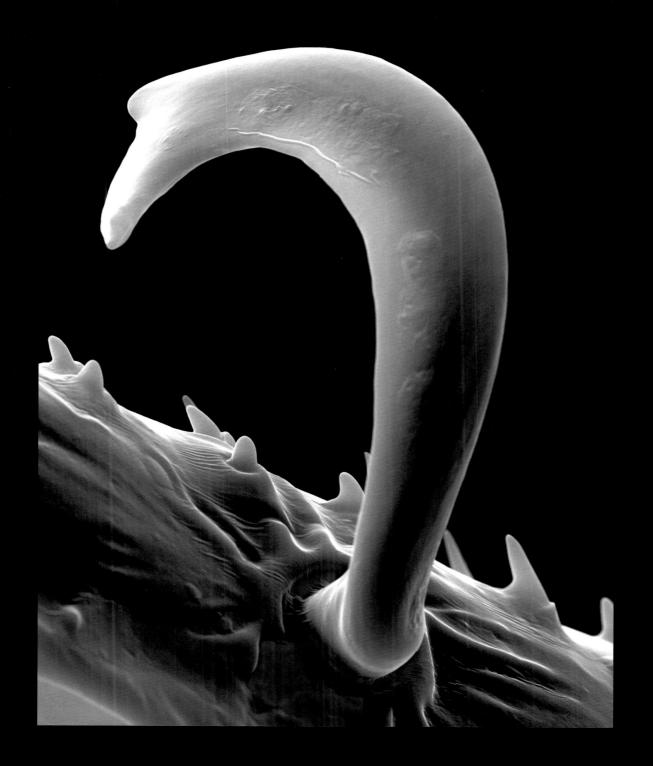

Velcro

Hooks along a bee's wing (and close-up)

IT IS IN THE INVISIBLE THAT BEAUTY SHINES...BUT WE ARE NOT
AWARE OF IT BECAUSE WE ARE MERE NOVICES OF PERCEPTION!

RELICS OF ATLANTIS

Skin folds of a juvenile flying fish

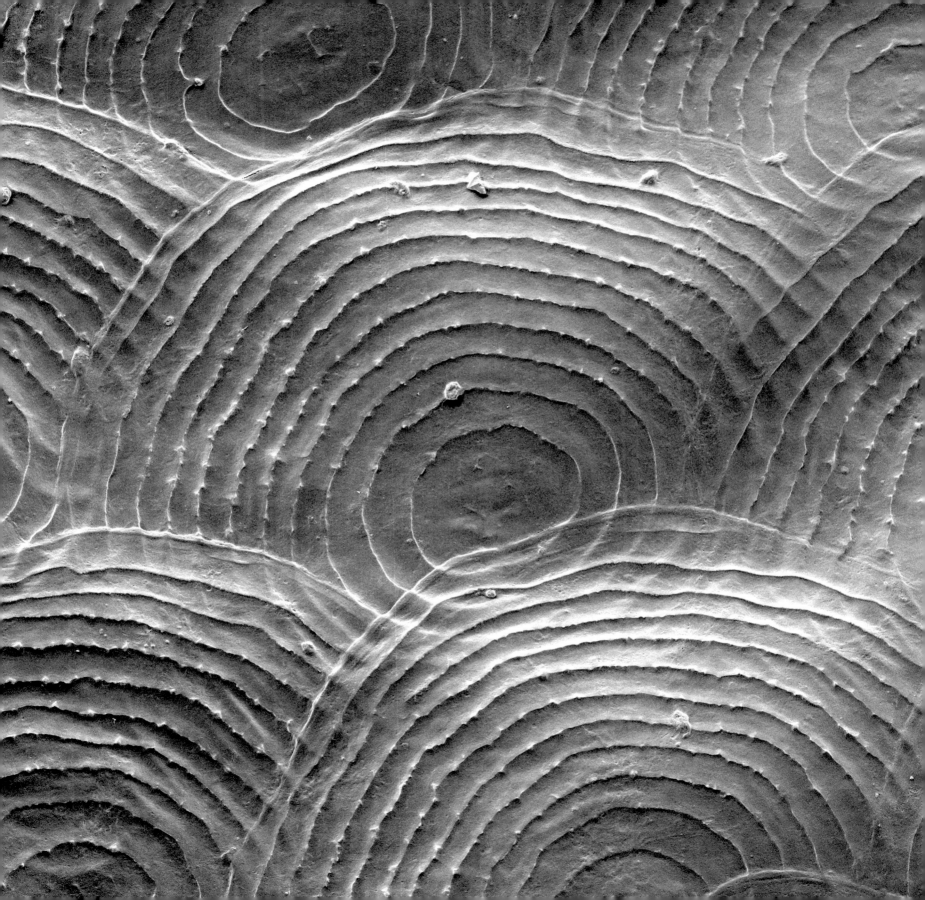

The Golden Age of Seeing

So many hands to transform this world and so few eyes to gaze upon it.
—Julien Gracq

It is astonishing to think that in the twenty-first century the explorer's lust for discovery may still be satisfied. Traveling to other planets is still not feasible for everyone, but if you have a passion for untouched territories, rest assured that while few men have walked on the moon, no one has crossed the microscopic craters of the little flower in your garden. So many unknown landscapes remain to be discovered, and who knows where tomorrow's microscopes will bring us! I hope that they will not be reserved for a handful of scientists. For any degree, the mere "desire" to contemplate should be the only prerequisite for admission into the school of *contemplative biology*. As drops of water erode mountains, so thousands of amazed eyes could bring to light nature's secrets. Their force could serve as an antidote to nature's abusive destruction. Beauty buried in the invisible is fragile and as our own survival depends on it, it is our duty to safeguard it. How dare we claim to improve nature and manipulate life without even taking the time to contemplate them?

Traveling through the invisible while transforming our perception expands the inner horizon. The variety of forms, the richness of textures both uncover an architecture in which the profound unity of the living world can be read. From its aesthetic diversity, nothing can be discarded, nothing is useless. Each plot of life is rich with meaning that escapes us, and unveils an absolute beauty that needs no witness. Beauty induces faith, or a feeling of cosmic consciousness, as if life were an artist working clay and stone to fill them with harmony and love. Leonardo da Vinci, Captain Cook, Pascal, Einstein—if only you could open your eyes one more time! Were it that you could send down to us a messenger enthused by your universal spirit to answer this question: Why is the invisible beautiful?

My explorer's journey became an initiation, because true sight is the vision of things unseen. During my quest, I discovered the most beautiful force of nature—beauty. It is a Holy Grail that has the magical power of awakening our senses, as well as a law of the universe that demands our respect.

Atlantis and its treasures may have been a myth, but those invisible worlds are very real. Discoverers of the invisible… onward! So many wonders are there to be discovered waiting to be gazed upon, and to live, we need to draw energy from the beauty of the world.

However, just like the horizon, the invisible is boundless. It cannot be grasped, possessed, or controlled. When we believe we have defined the invisible, it becomes even vaster and slips through our fingers as we hunt it down.

Star II

Underwater microplankton

Quiz

What do we know of this universe in which we evolve by feeling our way? If the visible is deceiving, the invisible does not easily yield its secrets. After many expeditions, I can still be mistaken. Seaweed can seem to be a star. I think I am looking at animal tissue, but they turn out to be plant cells. And then some mineral dares to adorn itself in vibrant embroideries.

Now it is for you to try.

ANSWERS AT THE END OF THE CHAPTER.

1

2

3

4

5

6

7

8

9

10

11

12

APPENDIXES

DETAILED CAPTIONS FOR THE PHOTOGRAPHS

The following remarks are here to assist the concerned reader to better identify the images in the photographs.

It must always be kept in mind that the purpose of my work is not to present a detailed description of plants and insects, nor to facilitate their classification. I have assiduously avoided all scientific terminology. My work must be seen as a collection of souvenirs in which I endeavored to capture and bring to life some "instants of wonderment."

If it enhances our understanding of biology, it does so simply by broadening our consciousness of this unsuspected universe that we brush up against in our daily lives. In traveling farther than our senses allow, beyond the limits of what we can discern, we discover a world of remarkable functional intelligence in which the forms of life, as microscopic as they may be, yield proof of an aesthetic harmony and virtuosity.

To reveal the hidden wonders of these inaccessible microworlds to the human eye, to initiate the layperson to their architectural richness and the reality of their artistic power—this has been my purpose.

Photographs of Flowers

PISTILS AND STAMEN

Flowering plants rule the plant kingdom. Flowers, with their fascinating diversity of shapes, aromas, and colors pursue a shared goal—reproduction. In their center is the female organ, the pistil (pages 31, 53, 93) that contains the ovaries. Its extremities gather and come to "know" the pollen seeds. Then, there are the stamens (pages 34, 35, 115), which are the male organs that produce pollen, the plant equivalent to spermatozoa. And finally, there are the petals. Sterile, they serve as billboards to attract insects. They are enclosed by sepals that protect the whole of the flower. As the Belgian writer Amélie Nothomb humorously wrote, "the flower is a giant sexual organ that is dressed to the nines."

31 34 35 53

93 115

THE CARRIERS

How can a plant, anchored to the ground by its roots, manage to transcend the often vast spaces that separate it from another plant and mix its genes? The answer, one of the most wonderful ones that evolution has come up with, lies in a pollen grain—a veritable plant astronaut (pages 30 and 55). Carried by the wind or affixed to the bristles of an insect, it releases a flower from its immobility. Fertilization is not achieved until a virgin female flower of the same species is found. There are only a few chances for success. Plants, rather than abandoning themselves to the whims of the wind, have also called upon the assistance of specialized carriers whom they have recruited by means of seduction. The architecture of the pollen grain enables it to adhere and affix itself to the hairs of an insect (pages 54 and 131). The insects, along with birds and bats, are paid for their efforts. They gorge on the sweet nectar or, like bees, feast on the rich pollen with which they nourish their larvæ.

MESSENGERS OF LOVE

From a few microns to a tenth of a millimeter, smooth or thorny, round or oval, these messages of love are produced millions at a time. To our eyes, they all look alike, but the electron microscope unveils the surprising modulation of their surfaces. Valleys, ridges, pores, concavities, bumps—each specific to a given species (pages 94–95, 129, 155, 157, 184, 185). These variations enable scientists to differentiate species and describe what vegetation existed thousands of years ago. And they did precisely that with the pollen found in Egyptian tombs and the caves of the Cro-Magnon.

94–95

129

155

157

184

185

30

54

55

55

131

FLORAL TISSUE: SEDUCTION AT ANY COST

The symbiotic relationship that exists between insects and flowers is the result of a long coevolution that is mutually beneficial for the partners. The plant ensures its continuity and the insect finds its sustenance. But it is not enough to offer a general round of nectar, the imbibers must still be enlightened! To this end, the flower has more than a strategy in its corolla. As soon as it is in blossom, the flower spreads far and wide its scent, a subtle scent that is perfectly adapted to the choice client. Some plants that are pollinated by flies exhale a putrid odor, while others (orchids, for example) mimic the sexual pheromones of its choice insects. The architecture of flowers, and above all the petals, like billboards are known for luring the consumers. Their bright colors compose variegated motifs, many of which are not perceptible to us, while for the insects they can designate veritable "landing strips." Their smooth appearance, either matte or velvety according to the surface of the epidermis, intensifies these variations in color (pages 25, 26, 27, 35, 171). As the electron microscope prohibits color perception, I have wondered what the real shade of a rose's cell is (page 115). And since the rose is a blend, which cells might reveal themselves to be blue or yellow? Here is a mystery that would make Impressionist painters happy!

THE BIRTH OF LEAVES AND FLOWERS

Dissecting a young bud under a microscope will reveal the embryonic cells (pages 117 and 196) enabling understanding of how, one by one, leaves and flowers are born following a geometric order that entails the golden section so dear to Leonardo da Vinci. The little balls covering the cells subsequently become structures that evoke a carpet of sea anemones. They gather themselves into a delicate duvet, which, like a plant cocoon, protects the leaf from dehydration. It is not known why and how they develop in different shapes throughout the plant kingdom (pages 118–119 and 183).

117

119

183

196

25

26

27

35

115

171

Photographs of Insects

Insects constitute the branch of the animal kingdom that has by far the greatest number of species. Today, more than a million have been counted, but this number is an underestimate as new species are being discovered every year.

 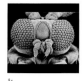

81 83 84 176

They have conquered all habitats, from the most arid deserts to the peaks of the Himalayas. Over the course of millions of years, they have developed an incredible capacity to adapt. From one one-hundredth of an inch to twenty inches (a quarter of a millimeter to fifty centimeters) long, they exhibit vast morphological differences even though the design of their anatomy remains relatively constant. In their adult form, they have six legs, a pair of antennæ, and usually two pairs of wings. Their bodies are divided into three segments: head, thorax, and abdomen.

THE HEAD

The head is the principal seat of the sensory organs, which comprise the eyes, two antennæ, three pairs of mouthparts, and an already very complex brain (pages 81, 83, 84, 176).

THE EYES

Sight is very important to the survival of an insect. It uses it not only to find its way, but also to look for sustenance and to escape predators. Adult insects have two kinds of eyes.

a) Compound Eyes

Globelike, they are situated on the sides of the head (pages 79, 84, 85) and are often iridescent. The facets, which generally are hexagonal, are arranged in a honeycomb and are visible to the naked human eye (pages 51, 121, 159). They are sometimes strewn with sensory hairs that react to vibrations in the air.

The facets (called ommatidia) make up a multitude of simple eyes which function independently from one another, each seeing a given image from an angle different from their neighbors. The images combine on the retina like a mosaic vision which gets finer as the number of facets increases. This characteristic compensates for the rudimentary nature of each simple eye, which does not give the insect a detailed sense of sight. However, their association enables it to discern the slightest movement, something we are well aware of when trying to catch a fly.

The number of facets depends on the lifestyle and thus, flying insects have many more than those that crawl on the ground. The eye of a dragonfly, that great hunter, has more than thirty thousand facets, whereas the eye of a butterfly or a bee has a few thousand and that of a worker ant, merely several hundred. Parasitic insects and those that live in caves often lack them completely.

b) Simple or Ocellar Eyes

In addition to the complex eyes, there are also simple eyes called ocelli (pages 79 and 131).

51 60–61 79 84

 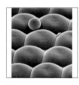

85 121 131 159

Most insects have three simple eyes, and in the case of primitive insects with no complex eyes, they are the only visual organs. Larvæ also have them but of a different internal structure (pages 60–61). The ocelli do not yield vision per se, but rather a perception of changes in light intensity. Of all insects, nocturnal ones are the best equipped in them.

THE MOUTH

Its different sections, called mouthparts, have an almost infinite variety of shapes. They are veritable tools that according to the specific diet serve to suck, lick, grind, chisel, carve, or puncture. Thus, those of blood-sucking and sap-sucking insects (mosquitoes and flower-bugs) (page 81) neither look alike nor have a similar sense of taste to those of wood- and seed-eating insects (beetles and ants) (page 83). With butterflies and houseflies (page 196), the mandibles and jaws have disappeared in favor of a suction tube.

THE ANTENNÆ

Numbering two, the mobile antennæ may be threadlike and lacy, evoking a feather or even a club (pages 80 and 86). They are covered in sensory scales or hairs that can count into the thousands and are specialized in the perception of touch, smell, air vibrations, and in all that allows the insect to enhance its awareness of its environment (page 27). The antennæ of many butterflies contain hairs that secrete scented molecules (sexual pheromones) and olfactory bristles that are so sensitive, a male is capable of picking out his female from many miles away (pages 160–161).

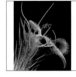 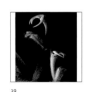 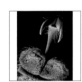 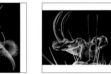

27 80 86 160–161

THE THORAX
THE LEGS

The thorax always has six and only six legs that are composed of many sections, some of which may be overdeveloped or absent and appear in various forms depending upon their function; that is, whether they are for carving, spinning, rowing, leaping, or capturing prey. They include structures specifically devoted to grooming, the emission of sounds, the gathering of food, as well as auditory, olfactory, and even occasionally taste organs. At the extremities there are generally two claws (pages 66 and 175).

19 66 91 175

 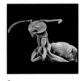 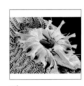

81 83 196

Those shown here, for example, allow the glowworm to crawl to the top of a twig where it will start to glow in order to attract its partner (page 19). Many insects have an adhesive pad between the claws that is covered with hairs, some of which end in a suction cup or secrete a sticky substance that enhances adhesion. This pad allows them to grasp on to smooth surfaces and explains the ease with which flies walk on the ceiling (page 91).

THE WINGS

In general, there are two pairs of wings, which in certain instances have become modified. With flies, for example, two of the wings are like pendulums, whereas with beetles, they have become stiff elytra and with some parasitic species, they have disappeared entirely. The speed of their flapping varies from two to a thousand times per second. The size of the wing determines the nature of flight, but for the most part, smaller species know how to make the most out of air currents. Wings can be translucent, colored and bristly (page 147), or with scales. With four-winged insects, the wings are edged with hooked hairs that, like Velcro, allow them to seal to one another as required by flight (page 188).

The scales may be long and fine or smooth in the shape of a racket and grouped together like roof tiles (page 149). Coloration occurs two different ways, either through an accumulation of pigment or through a clever microscopic architecture that prisms the rays of light and gives the insect an iridescence. These colorings and their arrangements serve to attract, intimidate, and camouflage.

147 149 188

THE ABDOMEN

The abdomen contains the digestive organs, the blood vessel, which is a long tube with a bulbous, pulsating section (the heart), and the nervous system, which looks like a knotted cord and is attached to the brain. The end of the abdomen bears various male and female reproductive organs. Pores can be seen along the length of the abdominal line (pages 127, 144, 153). These are respiratory holes. They open onto the tubes that branch out throughout the body to the tissues, delivering air. In fact, the blood, which is greenish in color, carries only food. It does not contain hemoglobin and is not capable of oxygenation. In small insects, air diffuses passively to all cells. In the largest ones, sacks of air are started up by the movement of the abdomen that acts like a pump and allows for the renewal of oxygen.

127 144 153

THE ARMOR (SKIN, ORNAMENTS, HAIRS, ETC.)

An insect's body is covered with hardened cuticles that form a veritable external skeleton. Its solidity serves as a defense against aggressors and physical accidents, and as it is waterproof, it protects against changes in the ambient humidity. This skeletal structure is formed of rigid, more or less articulated plates, upon which the muscles and tendons are attached. Contrary to the human internal skeleton, its skeleton cannot grow in size so the insect must go through a metamorphosis.

Like the armor of knights of the Middle Ages, the cuirass is often decorated with tiny sculpting and refined ornamentation (pages 123 and 125). The ridges, the spines, the horns, and the conical, spherical, and diamond-patterned granules vary according to the species, and the functions are still not fully explained (pages 65, 96, 145, 177).

65 96 97 123

125 145 150 151

173 177

In most of these sets, the skin is scattered with sensitive papillae and hairs and bristles, which are real living structures that contain epidermal or nerve cells. Some of these bristles, such as on many caterpillars, secrete a hive-inducing venom when lightly touched. The form and size of the bristle are quite varied: stiff, jagged or cabled, spread-out, spatula-like, or feathery (pages 97, 150, 151, 173). Most often, they serve some sensory function—whether touch, and even taste or hearing.

The scales are modified hairs and are no longer innervate. They are common among butterflies and form the "golden dust" of their wings, but they are also found on beetles and many other insects.

THE TRUTH ABOUT SPIDERS

Spiders—like mites, ticks, and scorpions—are not insects. In fact, they have eight feet while insects have only six. Their bodies are divided into two segments rather than three, the head and thorax being fused into a cephalothorax. Instead of antennæ, this segment sports "foot-jaws." Spiders breathe through primitive lungs and their abdomens have silk-producing glands. Spiders play an important ecological role by controlling the populations of insects whose proliferation could become dangerous (pages 32–33, 58–59, 88, 89).

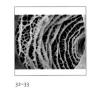 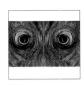 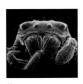

32–33 58–59 88 89

MICROSCOPIC PLANKTON ORGANISMS

Radiolarians, like amoebæ, are primitive living beings and are the principal component of plankton. Unicellular with sticky "arms" that can capture microscopic bacteria and algæ, they are truly floating predators. There are more than ten thousand of them in a single quart of seawater; however, they were even more abundant during the time of the dinosaurs. Composed of silica, their skeletons have remained intact in the sand at the depths of the ocean for two hundred and fifty million years. They are also found within the composition of flint. With richly ornamented spines and translucent pores or "wings" that seem to be made of glass, they form a clever and audacious architecture of geometric planes fascinating to viewers, reminding them that the microscopic concerns itself as much with complexity as it does with creative harmony (pages 9, 20, 21, 23, 143, 195, 196).

PHOTOGRAPHS OF THE MINERAL WORLD

The scanning microscope has proved to be extremely useful in studying minerals, as it provides precious information that the optical resolution of an ordinary microscope could not give. In the electronics and metallurgy industries, defects and fractures in computer chips or metal alloys can be detected (pages 63, 178–179). Thanks to this microscope, the astronautics industry can have more reliable and stronger materials at its disposal, and thus better control of resistance to corrosion and heat. Astronauts grow crystals (zeolite crystals, for example) in the weightlessness of space (pages 26, 57, 141), which affects how new properties are acquired. This will be beneficial to us in the near future, perhaps even in our daily lives (pages 38 and 39).

26 38 39 57

63 141 178–179

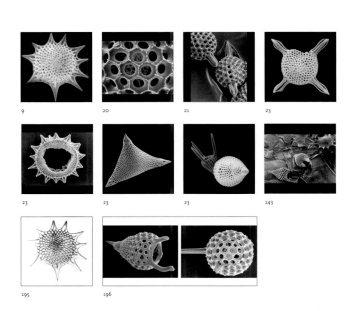

9 20 21 23

23 23 23 143

195 196

QUESTIONS OF SCALE

What is a scale of magnification? It is the number of times an image printed on a page of this book is enlarged in respect to the actual size of the object observed. A simple butterfly 1 ½ inches (4 centimeters) long enlarged ten thousand times would need a book 1,312 feet (400 meters) long to be seen in its entirety. Thus, only details can be printed.

I will limit myself to commenting on three types of scales, those most used in this work. In order to best communicate the sensation of dizziness that I felt, I will compare them to a similar magnification of a human being.

PORTRAITS

To show their "faces," a weak magnification on the order of tens or hundreds of times is used; such as is also accessible with a standard microscope, although with much less clarity.

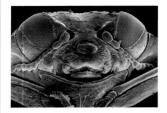

ENLARGED THREE HUN-
DRED AND THIRTY TIMES

Magnified on the scale of this image, our human being would be two times the height of the Eiffel Tower.

SCULPTURES

ENLARGED THREE
THOUSAND TIMES

Magnified three thousand times like the pollen grains here opposite, a human head would reach the clouds, some 17,715 feet (5,400 meters) in altitude, which is to say eighteen times the height of the Eiffel Tower.

17,715 FEET

Eiffel Tower: 984 feet (300 meters)

Finger: one times the tower

Head: two and a half times the tower

Ear: almost one times the tower

Tooth: 98 ½ feet (30 meters)

Bellybutton surface: 2,950 square feet (900 square meters)

Foot surface: 67 acres (27 hectares)

STRATOSPHERE
BIOSPHERE

MOUNT EVEREST

HIMALAYAS

ABSTRACTS

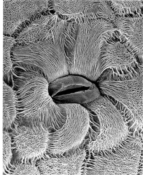

ENLARGED TEN
THOUSAND TIMES

Tooth: 328 feet (100 meters)

Finger: three times the Eiffel Tower

Head: eight times the Eiffel Tower

Bellybutton surface: 2 ½ acres (1 hectare)

Foot surface: 740 acres (300 hectares)

Height of Mount Everest: 29,000 feet (8, 848 meters)

On the scale of the intimacy of a rose, a human being would be two times the height of Mount Everest…and the wingspan of the butterfly would reach almost 1 ¼ miles (2 kilometers).

An electron scanning microscope can magnify to a much greater degree, something on the order of one hundred thousand to two hundred thousand times.

If one were to place Paris not in a bottle, but in a rosebud and then to look at it through an electron microscope, not only could the names of the streets be read, but also the title of this book on the shelf in some bookstore!

THERE'S NO RECIPE FOR EMBELLISHING ON NATURE,
IT'S ONLY ABOUT SEEING.
—AUGUSTE RODIN

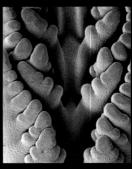

7. Birth of a fennel leaf

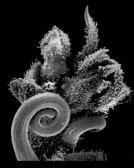

8. Birth of a bryony bud

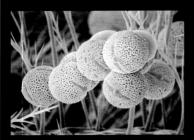

1. Pollen grains on bee hairs

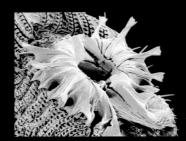

2. Mouth of a fly

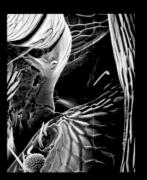

9. Pollen grain on beetle
head

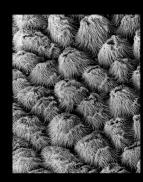

10. Borage flower petal

3. Plant hair

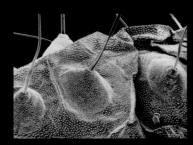

4. Back of a caterpillar

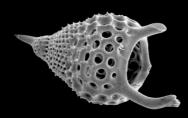

5 and 6. Underwater microplankton

11. Titanium alloy

12. Skin of a baby tarantula

FROM COLLECTING SPECIMENS
TO THE SHOOTING OF PHOTOGRAPHS

PROFESSION: MICRONAUT

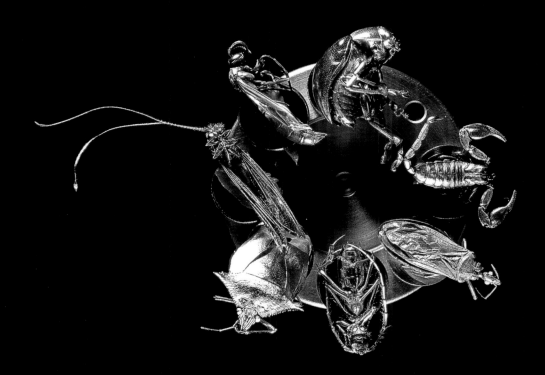

OR THE ART OF CONTEMPLATIVE BIOLOGY

Descent into the heart of the Grand Tsinggy Reserve in Madagascar, a vast forest of stone and one of the most "lunar" that one can explore on our planet. (Expedition directed by Nicolas Hulot)

To prepare them for observation under an electron microscope, the selected insects are anesthetized and cleaned while viewed through a binocular loupe. Preserved in alcohol, they will be carefully dehydrated once they reach the laboratory.

To make them conductive and also resistant to the physical constraints of the electron microscope, as well as to optimize observation, the specimens are covered in a fine coat of gold, a few microns thick.

The insect is placed under a leaf of gold in a sputter coater, saturated with fluorescent gas, which is then submitted to a powerful electrical current. A microscopic rain of gold falls down upon the insect and, without any alterations, brings to the fore the most infinitesimal reliefs. It is now ready to be placed in the chamber of the microscope.

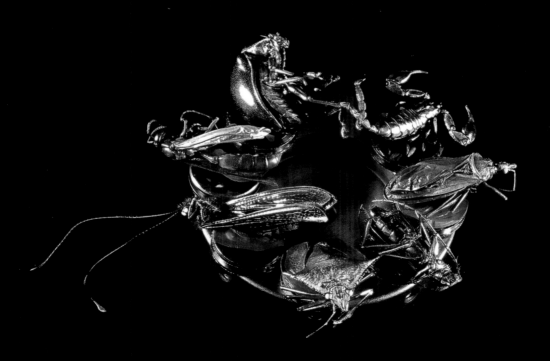

Finally, the exploration can begin. By varying the multiple adjustments of the microscope, different angles can be discovered and are there to linger over, one after another, as the images can be captured by a photographic device attached to the microscope.